Dickens

and

Prince

A Particular Kind of Genius

❦

Nick Hornby

RIVERHEAD BOOKS || NEW YORK || 2022

RIVERHEAD BOOKS
An imprint of Penguin Random House LLC
penguinrandomhouse.com

First published in hardcover in Great Britain by Viking,
an imprint of Penguin Random House Ltd., London, in 2022

First American edition published by Riverhead, 2022

Image credits: photo page 35 © André Cymone; photo page 104 Louis James
Collection; photo page 149 © Science Museum Group; photo page 154 Daily
Star/Mirrorpix cover image with photos by Max Mumbly/Getty Images, fabio
formaggio/Getty Images, Stephen Frink/Getty Images, EPN/Newscom, and
a photo courtesy of the Royal Society for the Prevention of Cruelty to Animals

Library of Congress Cataloging-in-Publication Data
Names: Hornby, Nick, author.
Title: Dickens and Prince : a particular kind of genius / Nick Hornby.
Description: New York : Riverhead Books, 2022.
Identifiers: LCCN 2022021919 (print) | LCCN 2022021920 (ebook) |
ISBN 9780593541821 (hardcover) | ISBN 9780593541838 (ebook)
Subjects: LCSH: Dickens, Charles, 1812-1870. | Prince. |
Dickens, Charles, 1812-1870—Appreciation. |
Prince—Appreciation. | LCGFT: Biographies.
Classification: LCC PR4581 .H57 2022 (print) |
LCC PR4581 (ebook) | DDC 823/.8—dc23/eng/20220822
LC record available at https://lccn.loc.gov/2022021919
LC ebook record available at https://lccn.loc.gov/2022021920

Printed in the United States of America
2nd Printing

BOOK DESIGN BY LUCIA BERNARD

To John Forrester, with thanks from everyone

He left a trail like a meteor, and everyone finds their own version . . . The child-victim, the irrepressibly ambitious young man . . . the demonic worker . . . The hater and lover of America. The giver of parties, the magician, the traveler . . . The dancer . . . the actor, the ham . . . The irreplaceable and unrepeatable . . . The brilliance in the room.

—CLAIRE TOMALIN, *CHARLES DICKENS: A LIFE*

Contents

ILLUSTRATIONS

Dickens
and
Prince

Introduction

There used to be a thing that did the rounds, a meme before memes existed, which pointed out the uncanny similarities between Abraham Lincoln and John Fitzgerald Kennedy: both were elected to Congress in '46 and became president in '60; both were shot in the head on a Friday; both lost a son while living in the White House; both were succeeded by Southern Democrats called Johnson; both were assassinated by men with three names, each composed of fifteen letters, and so on. Well, that's not what I'm going to attempt to do here. Charles John Huffman Dickens (twenty-five letters) was a white nineteenth-century writer, and Prince Nelson Rogers (eighteen letters) was a Black twentieth- and twenty-first-century musician. Dickens never heard anything that Prince recorded, and there is no evidence to suggest that Prince ever

read any Dickens.* I suppose one could argue feebly that they were and still are known by one name, but actually that's true of most famous artists. Yes, you have to say both Emily *and* Brontë, because of her siblings. And you have to say Michael *and* Jackson, a man who famously had siblings too, but whose extraordinary fame was never quite enough to stamp ownership on his very common surname. Using both names distinguishes him from Stonewall, and Jesse, and Samuel L., and Shoeless Joe (cf. Will and Maggie Smith, Tom and January Jones, Wilkie and Phil Collins, Jimmy and Rod Stewart). The one-name thing doesn't wash. When I was thinking about linking Prince and Dickens in an extended essay, I had one coincidence to work with: they were both fifty-eight years old when they died. But dying at fifty-eight in 2016, as Prince did, is not the same as dying at fifty-eight in 1870, as Dickens did. In the early nineteenth century your average life expectancy was forty years old on the day you were born, seventyish if you lived until your fortieth birthday. And on closer inspection, Prince wasn't fifty-eight when he died. He was fifty-seven. So I don't even have that.

* The closest they ever come to each other is in Bleak House. "Young Mr. Turveydrop's name is Prince; I wish it wasn't, because it sounds like a dog, but of course he didn't christen himself."

But here's what started it. In 2020, Prince's 1987 album *Sign o' the Times* was given the commemorative special boxed-set treatment. Usually, the rerelease of an iconic album will include anything extra that the record company can drag up—some live tracks, a few demos of the original songs, maybe a rejected song or two. *Sign o' the Times* included sixty-three songs that weren't on the original album. *Sixty-three!* That's almost four times as many as the original album, three more than Jimi Hendrix released in his lifetime, two more than the Eagles recorded in the twentieth century . . . and they were nearly all produced around the same time. (They weren't all produced for the same record, but we'll get to that.) The fan site PrinceVault has 102 entries in the category "Songs recorded during 1986." And we are beginning to learn that 1986 was not an atypical year. When I read about the boxed set, I thought, Who else ever produced this much? Who else ever worked that way? It was supposed to be a rhetorical question, but then I realized there was an answer: Dickens. Dickens did. Dickens worked that way.

Maybe there were other people who were just as prolific, although I doubt it, especially since Prince did a lot more than just record, and Dickens did a lot more than simply write novels. But I yoked them together in my mind at that moment because they are two of

what I shall have to describe, for want of a more exact term, as My People—the people I have thought about a lot, over the years, the artists who have shaped me, inspired me, made me think about my own work. I have scores of people like that, influences and role models and heroes. Galton and Simpson, Donald Fagen, Preston Sturges, Barbra Streisand, Robert Altman, Pauline Kael, Kurt Vonnegut, Stephen Sondheim, Mavis Staples, Arsène Wenger, Joan Didion, Anne Tyler, Jerry Seinfeld, Rickie Lee Jones, Aretha Franklin, Thierry Henry, Elizabeth Strout, Raymond Carver, Frederick Exley, Joe Henderson, Lorrie Moore, Edward Hopper, Liam Brady, Peter Blake, Bruce Springsteen, Emmylou Harris, Duke Ellington, Elizabeth McCracken, Larry McMurtry, Roddy Doyle, Tom Verlaine, Peter Wolf, Dave Eggers, Al Green, and many, many others. I won't go into detail about what they have all meant to me: sometimes it was their taste, sometimes their thinking, or their soul, or attention to detail, or audacity, or comic timing, or arrogance, or commitment, or bravery, or the way they have lived their lives. Anyone who has spent a lifetime consuming culture in all its forms at a possibly unhealthy rate has a similar list, and if you have spent your adult life creating something during the working day, that list is likely to be even longer, because

you need the input (and, let's face it, you have time that someone working on a production line or in a comprehensive school or a bank doesn't have). Prince and Dickens are two among many, but they are perhaps deserving of slightly larger type than some of the others. If anyone else did produce such a staggeringly enormous body of work, then it isn't someone I know much about. Maybe you're reading this and shouting, Wagner! Picasso! If you are, you'll have to write your own book.

I didn't read Dickens until I was at university, and I am grateful for that fluke of the mid-1970s school syllabus. If I had been forced to study him at school, then his greatness would have eluded me, as it has eluded lots of people I've met who are resistant to him, almost always because he was forced down their adolescent throats. "I must have been about nine years old when I first read *David Copperfield*," George Orwell said in an essay from *Inside the Whale*. "The mental atmosphere of the opening chapters was so immediately intelligible to me that I vaguely imagined they had been written by a child." Well, those days are gone, George. They were gone when I was at school, and there won't be many nine-year-olds reading *David Copperfield* in the foreseeable future, either. (And if you are the parent of a child who is doing precisely that right now, please stop them.

It will kill any future enjoyment they might get from those extraordinary novels. And also, you're a terrible parent.)

When Orwell was nine, *David Copperfield* had been around for about sixty years. Orwell's temporal relationship with the novel was the same as ours with *To Kill a Mockingbird* (published in 1960), another book that tells us a great deal about childhood—or one childhood, anyway. The language of the mid-twentieth century, however, is much more intelligible to us, and certainly to younger people, than the language of the Victorian novel, with its extended metaphors and the piles of subclauses. Harper Lee's novel is still read in schools because her child's-eye first person is extremely user-friendly, and its length is unintimidating (a hundred thousand words, compared to *David Copperfield*'s three hundred and fifty thousand).

It's just about possible to imagine a super-smart, Orwell-smart kid becoming engrossed in the story of Scout Finch, although of course the relationship between our young people and books has changed profoundly since Orwell's childhood, and since my own, and since the childhood of anyone who grew up in a pre-iPad age. I read everywhere, on interminable car journeys, and on trains, and in dentists' waiting rooms, and on wet Sunday afternoons, mainly because I was

bored stupid. I would not be a reader without the excruciating, never-ending, no-football-on-TV, shops-closed boredom that drove me toward the local library and, later, bookshops—neither open on Sunday, of course. My younger sons, both born in the twenty-first century, have never found themselves in the kind of stupor that would cause them to look upon literature as an escape, and though this is a cause for regret, I am also happy for them. Part of me wishes that I hadn't been bored enough to spend half my life with my head stuck in a book. Even so, desperate as I was, Dickens had the whiff of polite BBC early-evening costume drama clinging to him, and I gave him a wide berth.

I was twenty or twenty-one when I started *Bleak House*. Old enough. I'd read E. M. Forster at school, and Vonnegut and Nathanael West and Chandler at home, and the Dickens assignment, as I remember, came shortly after we—or my fellow students, anyway, because I didn't bother with very much of it—had been trudging through the Gawain Poet and *Piers Plowman* and probably something else that my Clash-loving younger self had found Heimlich-maneuver-level indigestible. And I remember two things: one, it was funny, and Dickens's turns of phrase and comic imagination were a complete surprise to me. Making people laugh, I realized incredulously, was important to him. Who

knew? Not me. The first time I laughed was in chapter 8, when Esther Summerson goes to visit the local poor with the do-gooder Mrs. Pardiggle. They invite themselves into the home of the local brickmaker; it's "one of a cluster of wretched hovels," a sock to Esther's system; there are "pigsties close to the broken windows," a "poor little gasping baby by the fire," a girl doing some kind of washing in dirty water, and the brickmaker lying on the floor, covered in filth, smoking a pipe. So far, so Dickens—or the Dickens I had imagined before I started reading him, describing poverty with anger and sympathy. But what comes next is a savagely comic tour de force, in which the brickmaker anticipates the do-gooder's questions and spits back the answers. "Have I read the little book wot you left? No, I an't read the little book wot you left. There an't nobody here as knows how to read it; and if there wos, it wouldn't be suitable to me. It's a book fit for a babby, and I'm not a babby. If you was to leave me a doll, I shouldn't nuss it. How have I been conducting of myself? Why, I've been drunk for three days; and I'd a been drunk four, if I'd a had the money . . . And how did my wife get that black eye? Why, I give it her; and if she says I didn't, she's a lie!"

I am trying to remember whether a book had ever

made me laugh at that point in my life. Books, it seemed to me, weren't, as a rule, funny. My experience of humor in literature to date was articulated by Rowan Atkinson's withering schoolteacher in a brilliant sketch from around that time. "Don't snigger, Babcock! It's not funny. *Antony and Cleopatra* is not a funny play. If Shakespeare had meant it to be funny, he would have put a joke in it. There is no joke in *Antony and Cleopatra . . .* What play of Shakespeare's does have a joke in it? Anyone? *The Comedy of Errors*, for God's sake! *The Comedy of Errors* has the joke of two people looking like each other. Twice."

That, to me, was the perfect summation of literary humor: people looked like each other, and we were supposed to laugh. Morecambe and Wise made me laugh, and *Taxi*, and *Fawlty Towers*, and my friends, but not books. That passage made me laugh out loud, however, and it seemed to be at the cutting edge of comedy. It wasn't cozy showbiz comedy; it was as cruel as *Fawlty Towers* and Monty Python, yet in Mrs. Pardiggle and Mrs. Jellyby, it also contained acute observation of a recognizable contemporary type. We have always been surrounded by people whose commitment to good works makes them crass, patronizing, and insensitive; we all know people whose commitment to the greater

problems of the world has led them to neglect their own families, as Mrs. Jellyby does.

And the second thing I remember during my initial exposure, just as I was realizing that I might have got Dickens wrong, is that there was this incredible moment when I felt the narrative start to move, like a giant tanker. The book was so monumental that it didn't occur to me that movement would even be possible; I thought I'd just be walking around on it idly until it was time to write an essay about it. I wasn't sure I would even finish it; my three years at university were littered with similar shipwrecks. But once it started moving, I could tell that it was just going to take me where it wanted to go, and I could neither stop it nor get off. I was a Dickens fan.

LIKE A LOT of people who listened to contemporary American R&B in the 1970s and 1980s, I became aware of Prince through his first hit, "I Wanna Be Your Lover." The ecstatically spring-heeled opening few seconds were all you needed to hear, if you already liked the Isley Brothers and Chic and Sly Stone. The song was the first track on the album *Prince*, which sounds like an introduction but wasn't: there had already been

a first album, *For You*, which flopped. Writing this, I can see that I came across Prince and Dickens in the same eighteen-month period, but of course it doesn't feel like that now, and it didn't feel like that then. Prince was a new musician, more or less a contemporary, not yet a big deal, and I was discovering someone like that every couple of weeks at the end of the 1970s. Dickens was part of the fabric of British life. He had his own adjective, and his characters have entered the language. So even though Prince and Dickens became two of "My People" during the same period of my life, I didn't know there were going to be "People," really, in that I didn't know that artists I liked were going to be used as ingredients for my own work, and I certainly wouldn't have known how to put a twenty-one-year-old R&B singer from Minneapolis alongside a one-hundred-and-sixty-seven-year-old writer from Portsmouth.

Anyway, I lost touch with Prince for a while after that album. I didn't think I was going to be very interested in a record called *Dirty Mind*. I began to suspect that Prince might prove to be a one-trick pony, and that the sex stuff was the one trick, a schtick, a smutty showbiz ruse during a time when I prized authenticity, whatever that meant. I was wrong, of course. The sex was authentic, a part of him, which ran through him like

writing in a stick of rock,* but as the decades went on, loving Prince meant having to ignore some loweringly lewd lyrics. (Before he died, he told at least one interviewer that he was celibate, a state possibly connected to his being a Jehovah's Witness, but I suspect that isn't how we'll end up thinking about him.) So he drifted from my vision until *1999* and, in particular, "Little Red Corvette" came out. "Little Red Corvette" still asks us to imagine a love object who keeps used condoms in her pocket without seeming to recognize that, for many of us, such a discovery would result in an early night alone and a long, nervous shower, rather than hours of erotic ecstasy. But the song is magnificent, with its dazzling singing, its irresistible hooks, its rather brilliant extended metaphors which manage to acknowledge both the excitement of the one-night stand and its dangers, and its sixties backbeat underneath a wash of post-disco synths. I loved the album *Purple Rain*, and I went to see the movie on the day it opened, but it was so bad, despite the music and the enthralling performances (have you tried to watch the movie since 1984, now that those

* American readers: when visiting an English seaside town, it is customary to buy a stick of rock—a baton of hard, usually pink-and-white candy, with the name of the seaside town running through it, so that you can still see the name with every bite you take. It is such a useful and frequently used metaphor that I can't imagine how you cope without it.

great songs are no longer unfamiliar?), that he still wasn't ushered into the VIP room of my brain.

And then, one night in August 1986, I saw him live for the first time, and it was sensational. The rock iconography and sound that had turned him into a global superstar were gone: this was like a James Brown show, one song segueing into the next, the large band—male dancers, a horn section—rehearsed to an astonishing level of perfection. And then there was Prince—Prince the great soul singer with the deep growl and the piercing falsetto, Prince the magnetic dancer, Prince the best guitar player in the world. The following year, *Sign o' the Times*, his best album, was released, and that was it. I saw him again a couple of times, but the next time, on the Lovesexy tour, as we should have guessed from the title, there were cars and beds onstage, and nowhere near as much music as I wanted and as I got the first time.

But as the years went on, it became apparent that Prince was a particular kind of genius. He couldn't stop writing, recording, playing. He couldn't dam up his creativity, and he didn't seem to want to anyway. He couldn't stop working. There actually aren't many artists with no off switch, and there aren't any at all, I don't think, among My People, apart from Prince and Dickens. What can we learn from looking at two artists,

both sui generis (which is why maybe the coupling isn't so odd), who literally had more than their fair share of talent? What did they do with it? Did it damage them in some way, personally, professionally? Is there any way of knowing where it came from? Did it kill them?

Childhood

Oh, and money was an issue for both of them when they were growing up. There were and are so many poor people in the world that it doesn't feel like much of a big deal, but they were truly great artists, and childhood poverty should have stopped them from achieving as much as they did. That's the way the world works, isn't it? It *is* still that way in many fields of endeavor, but during the twentieth century, art changed, and the people who made it changed too. Elvis Presley, Cary Grant, Louis Armstrong, Billie Holiday, James Brown, Jimi Hendrix, Charlie Chaplin, Dolly Parton, Leonardo DiCaprio, Jay-Z, giants in their fields, were all damagingly poor.

And then there were those household names who didn't starve, as far as one can tell, but whose parents were hardly prosperous, and sometimes in no position

to take care of their own kids. Richard Burton, one of thirteen children, son of a miner, was brought up by his sister; Marilyn Monroe became a ward of the state; James Dean was raised by his aunt and uncle; Marvin Gaye grew up in the projects of DC; Martin Scorsese, a chronic asthmatic, was born in Queens, and his parents worked in the Garment District. One could argue that they became famous *because* of their poverty rather than in spite of it. There's the need and drive to escape, of course, which we'll come to later. But they all learned to express themselves, and the lives they had led, in ways that made sense to millions of other people—either people who had shared their experience, or people who no longer seemed to want to hear from those who had led more privileged lives. (There were plenty of Ivy League students in the 1960s who loved Hendrix.)

And, crucially, the gatekeepers of popular culture usually came from similar backgrounds. No Ivy League graduates were running studios or record labels, or giving jobs to people they were at Eton with. Jack Warner of Warner Bros. was born to Polish-Jewish émigrés who had fled to Canada to escape the pogroms. Darryl Zanuck was born in Wahoo, Nebraska. Berry Gordy of Motown dropped out of school in the eleventh grade to become a boxer. Sam Phillips, owner of Sun Records

and the man who discovered Elvis, was the youngest of eight children, and picked cotton on his parents' mortgaged farm.

As you can see, I'm not scrabbling around for names, here. James Dean, Monroe, Elvis, Hendrix . . . You could have bought posters of most of these people in any branch of a Main Street music or poster store, in the days when such things existed. Warhol made lithographs of some of them. A private education can still buy you a university place, a professorship, a job in a law firm or a bank, a seat on the board of a major company, or a political career. One thing it apparently cannot buy you is superstardom in the field of the popular arts, which is only one reason among many that I love the popular arts. You could spend the rest of your cultural life watching, reading, and listening to people who grew up without access to much, and that cultural life would be rich and full—certainly much richer and fuller than that of someone who, for whatever reason, only wanted to consume stuff produced by those born into prosperous families.

Prince's troubles—and surprisingly little is known about his childhood, which he rarely discussed—seem to have stemmed from his parents' divorce. He may or may not have had epilepsy when he was little, and it

appears that he was abused, at least emotionally, by his stepfather. "Sometimes I think that the thing that Prince shared with other geniuses—Ray Charles, Bessie Smith, and James Brown—is that they were abandoned, at some level, by their mothers," said Questlove in a *Rolling Stone* piece published after Prince's death. "Many artists in black music were abandoned by fathers, but an absent mother creates a faultline that runs much deeper."

He went to live with his aunt and then eventually his father, but after some kind of row, possibly about sex and girls in the house, his father kicked him out. "Sometimes he'd talk about his past and about his family, which wasn't a happy subject for him," said Peggy McCreary, one of Prince's engineers. ". . . And also, his manager told me some stuff which shed some light into who he was. About how he grew up and didn't have a place to live and how by the time he was twelve he was out on the street, and how he lived in [his friend and bandmate] André's basement and his dad would come by every week or so and bring him cake . . . It was kind of rough. He was pretty much abandoned until he made it, and then of course everyone showed back up." If Prince and Dickens have been able to converse since their deaths, it's not hard to imagine that they would have alighted on the subject of people showing back up pretty quickly.

Dickens's poverty, unlike Prince's, is well-known and well-documented. His friend and first biographer John Forster quotes him directly in *The Life of Charles Dickens*, and his experiences were fictionalized in several of his novels. Twelve, once again, is the magic number: At this age, Dickens was sent to live, without his family, as a lodger in a boardinghouse run by unkind landlords. He was sent out to work in a blacking warehouse, while his father, his mother, and the younger members of his family were living in the Marshalsea, a debtors' prison. It's hard to say which of the two children, Prince or Dickens, had the more traumatic time, especially given Prince's reticence about his pre-fame period. Dickens's trauma was profound, obviously, but it came as a bolt from the blue, more or less, and the worst period was atypically brief.

Most children who experience an extreme version of poverty stay poor, but the Dickens family's financial ride was wild and bumpy. John Dickens earned a decent wage but was so incompetent with his money that his debts eventually caught up with him, at which point the Dickenses' slow descent through the Victorian gradations of class became precipitous. Yet there was a rise, of sorts, after the fall. John Dickens was pensioned out of the post office and found other work. Charles went back to school, and, astonishingly, his time in the

blacking factory was never mentioned again by his mother or father.

It is fairest to say that neither of them had it easy, especially during adolescence. It wouldn't be inaccurate to describe both of these young lives as Dickensian, and one could use the same word to describe the childhoods of many of the icons in the lists above. Very few of them were simply poor the way Dolly Parton was poor—a one-room shack, eleven siblings, two parents. It was poverty plus catastrophe with Marilyn, James Dean (clearly another member of the two-name club), Hendrix, Chaplin: parental abandonment or death, violence, abuse. Several of these twentieth-century icons were raised by someone other than their mother and father at some point in their lives. These things are more likely to happen to the poor, but even so they surely lengthen the odds against extraordinary achievement still further.

So what did they do with their catastrophes, Prince and Dickens? When Prince still lived at home, he had access to the piano that his father, a professional pianist, had left behind. (He had his own jazz band that Andre's father was also a part of.) Prince's stepfather locked him away for long periods of time, but during those hours he had something to do, something that would eventually come in very useful. Andre Anderson,

whose parents owned the basement where Prince holed up after he moved out, was a member of the teenage Prince's band, and it appears as though their instruments were stored right there, where Prince slept. What went on in Andre's basement? Presumably the same kinds of things that had caused ructions with his father, but that can't have been the whole story. Prince is as good a drummer, keyboard player, and bassist as just about anyone he would ever employ, and a superlative guitarist. His is the only name in the credits of *For You*, the first album. All tracks were written, produced, sung, and played by him, and him alone—every song, every instrument, every backing vocal. He was twenty years old, and it is hard to imagine that his spell of basement dwelling had nothing to do with this rather startling demonstration of virtuosity.

THE FIRST TIME Dickens went to see his father in the Marshalsea, John Dickens told him that an income of £20 and an expenditure of £19 19s 6d meant happiness, but an expenditure of £21 would produce a different outcome. In other words, one of the most famous characters in English literature was born more or less the moment Dickens walked through the prison gates. *David Copperfield*'s Micawber embodies a state

of deluded optimism, and his name soon entered the language—he has an "ism" and a principle. (People tend to forget that Micawber's optimism did eventually pay off, and that he sails away to a smart new job in Australia.) But just the day before his imprisonment, John Dickens told his son that the sun was setting on him forever, thus reducing Charles to deep despair. The Marshalsea episode happened in the mid-1820s, but Micawber first appeared in public in the late 1840s. Maybe it took that long to see any kind of fond comedy in his father's awful plight (although *Oliver Twist*, which must in part have come from the author's trauma and shame, was written in the 1830s, while Dickens was in his midtwenties), but Dickens managed it in the end. His experiences always became art, transformed by his imagination into something with meaning, resonance, and, frequently, humor.

The influence of these miserable and frightening years is everywhere in his books. "Little" Amy Dorrit is a "child of the Marshalsea," but there are lots of other children in Dickens's great novels, all suffering—poor, put to work too early, at the whim of inadequate or feckless or simply unfortunate parents. "They were not his clients whose cause he pleaded with such pathos and humor, and on whose side he got the laughter and tears of all the world, but in some sense his very self," said

Forster. Prince, it's fair to say, wrote more about sex than he did about society, and when he did write songs about the world outside his window—"Sign o' the Times," "Baltimore"—they were protest songs, like Dylan's early work. He is an impassioned observer. Whatever happened when he was a boy stayed buried, as far as we can tell, or was at least approached very glancingly.

Talent, psychologist Dean Keith Simonton has suggested, is "best thought of as any package of personal characteristics that accelerates the acquisition of expertise." It seems clear to me that Dickens was going to be a writer and Prince was going to be a musician no matter what. The "package of personal characteristics"— Dickens's powers of observation and mimicry, Prince's hunger for music and his aptitude for any instrument he could lay his hands on—was there at an early age, and could only result in those outcomes. But the kind of talent they possessed was clearly shaped by their singular experiences in those formative years, and more or less the moment they ceased to be teenagers, they both caught fire and lit up the world.

Their Twenties

They didn't hang around.

Before he was thirty, Prince had written "I Feel for You," "Controversy," "1999," "Little Red Corvette," "Let's Go Crazy," "Purple Rain," "When Doves Cry," "Raspberry Beret," "Pop Life," "Girls & Boys," "Kiss," "Sign o' the Times," and "Alphabet Street." Between his twenty-fourth and twenty-ninth birthdays, there was a run of five albums (*1999*, *Purple Rain*, *Around the World in a Day*, *Parade*, and *Sign o' the Times*) that would match any creative hot streak in the history of popular music.

One has to be careful here. Yes, he was very young when he started, but so was everybody. Pop music, even great pop music, is made by young people, and the best work is always made in the early part of the career. Lots of people have made great albums long

after their initial impact—Dylan, certainly, a few others. But the stuff that lasts—*Sgt. Pepper, Astral Weeks, Exile on Main St., Blue, Blonde on Blonde, Off the Wall, It Takes a Nation of Millions to Hold Us Back, Spirit in the Dark, Nevermind, Tapestry, Pet Sounds*, and the rest—was all made by people in their twenties. So was there anything different about Prince? Maybe.

First of all, his run of five great albums in six years came when artists didn't have to do what their predecessors had done. The demands of the market were different. The Beatles released their thirteen albums in the seven years between 1963 and 1970 because that was what was expected and needed by a record company, certainly in the early to midsixties. By contrast, Prince's most obvious rival, Michael Jackson, produced just two records, *Thriller* and *Bad*, in the 1980s, the decade in which Prince produced nine. And yes, *Thriller* was the more successful record, but Prince hardly needed the money after the success of *Purple Rain* the album and *Purple Rain* the film. In 2014, the composer, songwriter, arranger, and recording artist Van Dyke Parks wrote a song with Ringo Starr called "Bamboula"; he estimated that, with one hundred thousand plays on Spotify, it would earn him $32. "Forty years ago, co-writing a song with Ringo Starr would have

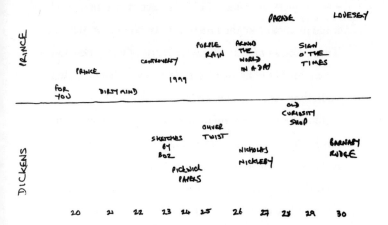

provided me with a house and a pool." Imagine how many houses and pools the biggest Prince album, with its five hit singles, would have bought him. There was no need for Prince to make as many records as he did.

And second, he was on his own. There was no John or Keith to write songs with. (Someone does get a co-credit for a couple of songs on the first album, but we'll come to him later.) He knew other musicians, and by the time we get to *Purple Rain*, Wendy Melvoin and Lisa Coleman played an important role in the realization of some of his best music. But on that first album, made, remember, when he was twenty, there was nobody else even to bang a cymbal. And yes, Dylan's first

solo records consisted of him, an acoustic guitar, and a harmonica, but they were not ambitious musically. Those songs made an impact because of what they had to say and how he delivered that news. Prince didn't walk that way.

Two of the songs on Dylan's first album were written by him. The rest were either traditional songs or covers. The Beatles wrote just over half of their first record; the Stones wrote three of the twelve tracks on theirs. They could use their time in the studio to learn how to put their live acts, the songs they had been playing for a while, on tape. Meanwhile, they learned how to write. Prince covered songs all the time in live performances, especially later, but no covers appeared on his regular albums until 1996, eighteen years after he'd started, seventeen albums into his career. And no other musician is credited at all until his third album, on which Lisa Coleman sang backing vocals on the track "Head," and Dr. Fink played synthesizer on two tracks. Twenty-four songs out of the first twenty-six had no input from any other musician, even though all the songs were effectively written for and played by a full band.

Why was he so accomplished in the studio, from such a young age? It seems as though, surprisingly, the English can take some of the credit for the technical proficiency of a young Black man in Minneapolis.

Grand Central, Prince's band, now called Champagne or, more regrettably, Shampayne, spent a little of the money that it had earned from playing gigs around the city on cheap studio rentals; the cheapest was called Moon Sound, run by an Englishman called Chris Moon. Moon, a frustrated songwriter, was impressed by Prince's dedication, discipline, and chops, and he made him an offer. If Prince set Moon's lyrics to music, Moon would give him free studio time for his own stuff. Prince was even promised a key to Moon Sound. The other members of Shampayne were irritated by the competition for Prince's talents and time and gave him an ultimatum: the band or Moon.

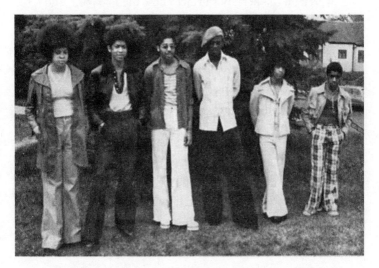

Prince (second from right) and Grand Central, 1974

This is a big moment. It is fair to say that not many of us would have struggled to choose, faced with the same options. It's not just that we might have felt some sense of loyalty to our fellow band members, and it's not just that being in a band with mates is irresistible fun when you're young. We would also have needed to be utterly convinced of our ability to exploit the opportunity to do something more or less on our own, a lot of it involving repetition, mistakes, and knob twiddling. Champagne or Shampayne had talent. Morris Day, later of the Time and a star of the *Purple Rain* movie, played the drums. Andre Anderson, later André Cymone, still has a recording career. They certainly weren't no-hopers. But Prince chose the solo path, and Champagne or Shampayne continued without him. I could honestly say that I would still be playing weddings and bar mitzvahs with Champagne or Shampayne now, if they'd have me. It's no coincidence that my first book was published when I was thirty-five years old.

Prince apparently spent every spare hour he had in the studio from that point. To begin with, those hours came after school and on weekends, and then, when he graduated from high school, they constituted his life. Two of the songs, including his first single, "Soft and Wet," were co-written with Chris Moon, a man who

puts himself, forgivably, at the center of the early Prince story. Moon, according to Moon, taught Prince to sing, to use the studio, to write and structure songs. Moon even decided on his stage name, a claim that takes some swallowing given that Prince's stage name was his actual name. Moon told *Billboard* that Prince insisted, nonnegotiably, he would be the artist known as Mr. Nelson. "I said, 'Fortunately you're a Prince! You have the perfect name for an artist. It couldn't be any better, and it doesn't need to be anything more than that one word' . . . And he looks at me and he says, 'I will never use that name. I hate that name because in school they always used to tease me and call me "Princess" and stuff like that . . . I want to be known as Mr. Nelson, and there is no room for discussion on this.' So I said, 'Look, here's the first problem: There's already a Mr. Nelson out there. His name is Willie. And besides, I just don't think that name's as strong as Prince.'" Whoever is responsible for Prince's early success—and despite Mr. Moon's claims, I would argue that Prince should get the lion's share of the credit—the dizzying jump from Andre Anderson's basement to the global stage clearly became shorter during this period. "There are times," Moon said, "when I think that if I hadn't discovered him—and let's say he had never become famous—then he might have married an average girl and lived in an

average house and had a couple of average kids." With respect, I don't think so, Chris. Prince was always going to be Prince. Indeed, he already was.

AND HOW DO you go from working in a blacking factory to becoming a celebrated author in your midtwenties? Dickens left school at fifteen—money troubles at home, again—and got a job as a clerk at a lawyer's office in Gray's Inn, one of London's Inns of Court. He moved from job to job, taught himself shorthand, became a reporter in the Doctors' Commons, the ecclesiastical legal society near St. Paul's Cathedral—not glamorous or well-paid work, but a step into the field of writing. He reported on divorces and wills, and you can almost see the work being poured into the writer's head: lawyers, legal suits, complicated and mysterious estates, glug glug glug. He fell in love, and, in order to make himself more eligible, he started hustling an uncle for work as a parliamentary reporter (glug). Eventually he started writing sketches of London life under the pen name "Boz" in a newspaper, and those sketches started to become fictional, and they brought him attention. When they were published in book form, still under the pen name Boz, they were well reviewed and they sold. Another admiring publisher ap-

proached him to write sketches accompanying a series of drawings; this book became *The Posthumous Papers of the Pickwick Club*, also by "Boz."

The Pickwick Papers—which appeared, as would become the pattern for Dickens, in monthly installments—got off to a rocky start. The first issue sold four hundred copies. But then Dickens introduced a new comic character, Sam Weller, a cockney, who promptly took over the book, and suddenly both the serialization and Dickens were propelled straight up in the air like a rocket. *Pickwick* eventually hit forty thousand copies a month, and Dickens would be famous for the rest of his life. "Each number sold for a shilling and they were passed from hand to hand, and butchers' boys were seen reading them in the streets," says Claire Tomalin in her magnificent biography. "Judges and politicians, the middle classes and the rich, bought them, read them and applauded; and the ordinary people saw that they were on his side, and they loved him for it." The cheap form brought with it new readers. The book business was in a mess when Dickens began to publish. As John Sutherland points out in his book *Victorian Fiction*, the financial slump in the early 1830s had "stripped out" the English book trade. It had become harder to buy books. That was the world into which *Pickwick* was released. "In numbers"—i.e., serialized parts—"the novel

could sell independently of the booksellers like the newspaper, at a time when newspapers were becoming a national medium." Only Thackeray, however, with *Vanity Fair*, had any kind of hit in the form, and even then his sales—just over five thousand per issue—were dwarfed by the thirty-five thousand that Dickens got for *Bleak House*. We now tend to think that all Victorian fiction was published in installments, but it was only Dickens who was repeatedly successful, and he stayed loyal to them, right up until his death.

Pickwick was ripped off—several authors wrote several further adventures—and Sam Weller went viral, as it were, with his own spin-off, *Sam Weller's Pickwick Jest-Book*. The title-page promises "ALL THE FUNNY SAYINGS OF SAM AND HIS COMPANIONS, AND UPWARD OF 1000 Jokes, Puns, Epigrams, Jeux D'Esprit etc." Even before Dickens invented Christmas, he clearly if inadvertently invented the stocking filler, too. It is comical to look at the attempts of publishers to replicate *Pickwick*'s magic, and what makes it funnier is that they seem to have learned little in the last one hundred and eighty-odd years. How many new *Bridget Jones*es have there been? How many *White Teeth*s and *Gone Girls*? Every time something hits big, there are scores of attempts to imitate the success, even

though the freshness and originality of the originals were responsible for the success in the first place. After *The Pickwick Papers* and *Nicholas Nickleby*, Victorian publishers decided, like particularly slow-witted detectives, that the secret to the mystery was in the alliteration. So watch out! Here come *Valentine Vox the Ventriloquist*, *Will's Whim, Consisting of Characteristic Curiosities, Charley Cox*, and *David Dreamy*. When that failed, they rushed to Dickens's illustrator, "Phiz," who was, says John Sutherland, "showered with more commissions than he could conscientiously fulfill." There was no secret. There was no mystery. *The Pickwick Papers* was successful because it had been written by an extraordinary talent. Dickens was twenty-four years old.

Prince's progress toward that level of success was a little slower, but then, he started earlier. Dickens made it in one hundred meters, boom, like Usain Bolt; Prince needed a longer distance, even though he and Dickens pretty much ended up in the same place at the same age, and in any case, a three-album deal with Warner's at eighteen (although he may have shaved a year or so off his age to emphasize his prodigiousness) is hardly abject failure. He was the youngest artist ever to have been backed that heavily. In Minneapolis, he'd gotten himself a manager, and the manager got him a record

deal. It was with Warner's because they were the only company that would give him both the length of contract he wanted and a role as a producer. For someone still in his teens, he had some very firm ideas. The record that came out fell into the traps that maybe his enemies could have set themselves, if they were being mean. It's self-consciously accomplished, almost over-musical, punctilious and airless, with way too many vocal overdubs, and there wasn't a hit song on it—by which I mean, there wasn't a track that poked its head above the rest of them in a way that might make people want to listen to it over and over again. By which I mean, none of the tracks were that great. In one sense, Prince's youth and precocity, and his unusual access to studios, had undone him. "Prince was largely bored of songs like 'Just as Long as We're Together,' which further robbed them of any freshness," say Alex Hahn and Laura Tiebert in their book *The Rise of Prince*. *Please Please Me*, the Beatles' first album, was famously recorded in one twelve-hour session, and couldn't help but sound fresh. This wasn't how Prince did things, at least at this stage of his career. For him, it seemed, every aspect of his talent and ambition was being judged, and he wanted to show them all off, all at once, and there were simply too many of them.

There were four albums in the first three or four

years of Prince's twenties. He got a lot of good reviews for the third album, *Dirty Mind*—in *The Village Voice*, Robert Christgau gave it an A rating and said that "Mick Jagger should fold up his penis and go home." (He said this in reference to the carnality of the record, by the way—it wasn't just general advice for Jagger.) The trouble with making an album called *Dirty Mind*— and the songs were a direct expression of that mind—is that you don't get much radio play, and once again there were no hits. *Controversy*, the fourth album, had some great songs, but the lyrics were still problematic for mass media. "Do Me, Baby" is one of Prince's most beautiful ballads, but there is the sound of a protracted orgasm that adds a couple of minutes to its length. This orgasm was pretend, at least. Later on, Prince would use a real one belonging to his on-again off-again lover Jill Jones (presumably on-again at the time of recording). The rhyme for "private joy" is "pretty toy," which would be enough for cancellation now, and made one feel a little queasy back then. He also calls his lover an "orgasma-tron," which was funny in Woody Allen's *Sleeper* and remains funny here, unfortunately. "Controversy" is driven by a robotic but funky propulsion, and there's a great catchy chorus, but the spoken chant toward the end pairs "rude" and "nude," a rhyme familiar to any parent of an eight-year-old.

If Dickens and Prince were to compare notes about their nascent, pre-breakthrough careers, I suspect that Dickens might be grateful for the years of anonymity spent wandering the streets, parliamentary offices, and law courts of London. There was the material that these years provided, and yet there was no chance of public humiliation. Prince had to abort a supporting gig with the Rolling Stones because the racist and homophobic Disco Sucks crowd jeered and threw stuff at him; the record company came to see him perform a showcase gig and decided he wasn't ready for a national tour. The introduction to his first appearance on TV, on the late-night entertainment show *The Midnight Special*, was made by Ray Sawyer and Dennis Locorriere of Dr. Hook—not a good fit, and made even more uncomfortable by the young man's stage outfit, which consisted of a skimpy zebra-striped pouch, what looked like thigh-high boots, and a bare chest wrapped in some kind of gold lamé shawl. Maybe if Dickens had been given a lucrative three-book deal in his teens before he'd written a word of fiction, he'd have felt the pressure and the desperation, too.

And then, in 1982, Prince's long-predicted and possibly overdue breakthrough, the occasionally brilliant, occasionally messy double album *1999*. Two *Billboard*

top ten singles, one top twenty single, a Grammy nomination, eventually certified quadruple platinum. He was twenty-four years old.

One thing to note here: MTV began broadcasting in 1981, so the videos for "Little Red Corvette" and the title track of the album got heavy rotation. Prince was paralyzingly shy. After the *Midnight Special* performance, he was on *American Bandstand*, and there was an excruciating, monosyllabic interview with the veteran host Dick Clark. There were many such interviews throughout his career, too, interviews in which he refused to engage with the questions, or gave silly answers. Early on, recalls Bob Merlis, the former head of publicity at Warner's, he asked a woman journalist if her pubic hair grew up to her navel. Sometimes, to be a fan of Prince was to be cast back to one's school days, struggling to defend an inarticulate and possibly malodorous guitar hero while he postured and pranced on TV in front of my witheringly scornful mother.

The print run of most Victorian novels was five hundred copies, sometimes seven hundred and fifty. Jane Austen's *Emma*, published twenty-one years before *Pickwick*, was a notable success, and sold two thousand copies, but the novel-reading public was small—a

long way from the forty thousand per issue that Dickens got. Through serialization, he found a way to connect with a readership that circumvented some of the more conventional routes to publishing success. Through MTV, Prince could be beamed straight into the living rooms and—as families started to own more and more consumer goods in the 1980s—the bedrooms of his natural audience.

AT THIS POINT, it might be useful to address the theory, originally proposed in a Swedish 1993 paper entitled "The Role of Deliberate Practice in the Acquisition of Expert Performance" and popularized by Malcolm Gladwell in his book *Outliers*, that genius cannot be attained without ten thousand hours of practice. Since the publication of the Gladwell book, there has been some pushback on this idea. A study attempting to replicate the 1993 test found that factors other than practice were responsible for elevating a musician or a sportsman into the superelite level. How much did Prince "practice" before he broke through? He'd been teaching himself for most of his life—playing in bands, writing songs, messing around with his father's piano. And there had been the invaluable opportunity to

learn in the studio with Chris Moon. I don't know whether this qualifies as disciplined training in the *Outliers* sense, but I don't think Prince's talent or success can be explained in this way. And as for Dickens: forget it. He'd been writing for the Gladwell equivalent of five minutes before *Pickwick*. He wasn't yet at the very top of his game, admittedly—we're still thirteen years away from *David Copperfield*. But his first novel is still in print, beloved now, beloved then. He was great and successful more or less immediately. His writing was uncreative until he began to write the sketches that became his first book. While I was writing my first book I can remember spending two days reviewing audiobooks that, between you and me, I hadn't bothered listening to, for the holiday section of a magazine that nobody read, and I can say with supreme confidence that not a single second of the experience was useful to me, although it probably fed the desperation to make my book *Fever Pitch* as good as it could possibly be. Maybe Dickens sharpened his hunger in the Doctors' Commons, the law offices where he spent the first part of his career, and as we have seen, his early professional experiences certainly provided him with material—but then again, the simple acts of living and observing do the same job.

There is a lovely moment in *The Beautiful Ones*, Prince's uncompleted memoir, when he describes the day that his father took him to see the movie of the Woodstock festival.

> . . . [My] father smiled and said OK I'll take you on Sunday afternoon after church . . . Of course, that was the longest service I ever had to sit through. Service in the Black church is long to begin with, but the thought of spending the night with Santana, Jimi Hendrix and Sly & The Family Stone was too much to handle . . . The bond we cemented that very night let me know that there would always b someone in my corner when it came 2 my passion. My father understood that night what music really meant 2 me.

This seems to have happened when the movie was released, in which case Prince was around twelve years old—awfully young for that level of passion and anticipation. Elsewhere in the book, he talks about the importance of one of his first babysitting gigs, for a local celebrity DJ called Jerry "Motormouth" Mac. "Countless hours I would spend in Jerry's basement looking at all the 8 by 10 glossies of the greatest R&B stars . . . Jerry introduced me to Dee, the local record store

owner. We never rode past Dee's record shop without stopping in. Any song that caught my fancy was 1st purchased and then transcribed.* Lyrics only, as I never learned 2 read music. Re-copying a lyric helps you to break down a line, to see what it's made of." What kid does that? A very select few. Questlove, drummer for the Roots, writer, director, and one-man music historian, directly involved in much of the greatest Black music of the twenty-first century, talked in an essay about his struggle to buy and keep the salacious *1999* in a born-again Christian house:

"My mom found the record and threw it away. Winter came. I shoveled snow until I had enough money to buy it a second time. That one went into the garbage, too. There was a third record that just vanished without a trace, and a fourth that got broken over my father's knee. That fourth infraction came accompanied by a month of punishment. A little while after that, I got smarter, meaning sneakier. I found a friend to make me cassettes of Prince's albums. At home, I loosened the heads of my drums and hid the contraband in there. I listened when I was practicing, playing something totally different on the drums so that my

* Prince's tastes as a kid were eclectic, too. He was a Led Zeppelin fan. He was even a Grand Funk Railroad fan.

parents wouldn't know what I was actually hearing." What kind of kid loves a musician that much? You can make an unwilling, frequently tearful young person scrape away at a violin or bash the keys of a piano once a week, but you can't make them love music as much as it needs to be loved for a musical career to ensue. Those kids, the ones destined for recording studios and auditoriums, are self-selecting.

For Dickens, there were books, of course. He was a writer, after all, and when he was finally, at the age of eighteen, allowed to apply for a ticket to the Reading Room at the British Museum, he read whenever he could in there. But also around that time he started going to the theater, and thought seriously about becoming an actor. He didn't just go to the theater, though, just as Questlove didn't just listen to *1999*, and Prince didn't just listen to records. Dickens claims that he went to the theater nearly every night for three years. He was particularly obsessed with a performer/comedian called Charles Mathews, and Dickens saw his shows "as often as he could, learning his performances by heart, words, songs, movements and gestures," Claire Tomalin wrote. What kind of teenager does that?

So perhaps it's not ten thousand hours of practice

that counts; maybe it's ten thousand hours of consumption. Prince and Dickens (and Questlove, whose talents and accomplishments are startling) didn't just enjoy their stuff, their plays and singles and albums. They inhaled them—took them apart, learned them, copied them word for word and note for note. I am closer to being Dickens than I am to being Prince, although of course that's a bit like saying I'm closer to Mars than to Saturn. But I suspect my degree of passion for books, music, TV, and movies has never been "normal." It was certainly big enough to make me never want a proper job; I wanted to get as close as possible to the place where people created these things.

So there we are. Ten thousand hours of consumption is the minimum requirement for entry into the Genius Club. But of course, as many of us have found out, ten thousand hours aren't enough on their own, without the genius. And what made us so hungry in the first place? What caused the appetite to be so sharp, so insatiable, when so many other people simply take pleasure in listening to music sometimes, or watching the TV of an evening? In John Carey's brilliant book *What Good Are the Arts?*, he demolishes, one by one, all the lessons and rules and theories that people have applied to culture and its significance—their attempts to "prove,"

through science or logic or philosophy, that great art does *this* to you, and is better than not-great art because it has *that*. Ostensibly clever people—Hume, Kant, Schopenhauer, Edmund Wilson—have tied themselves in knots trying to explain why, say, Verdi's *Rigoletto* is better than, say, Prince's "Sexy MF" (and yes, thanks, I know that none of them listened to "Sexy MF"). Carey refers to a book called *Psychology of the Arts*, "a mammoth survey . . . incorporating the results of over a hundred years of investigation in experimental esthetics, sociology, anthropology and psychology. The bibliography runs to 1500 items."

Rather bathetically, the authors, Hans Kreitler and Shulamith Kreitler, concluded that we like what we like. "As for the question *why* different people respond differently to the same work, the Kreitlers agree, in effect, with Virginia Woolf, that it cannot be known, or rather that to answer it your knowledge would have to be virtually infinite. It would have 'to extend over an immeasurably large range of variables, which would include not only perceptual, cognitive, emotional and other personality characteristics, but also biographical data, specific personal experiences, past encounters with art, and individual memories and associations.'" I suspect the answer to the question "What made Prince and

Dickens loopy about popular music and the theater?" would be similar. Every tiny step of their lives, every single parental decision, school lesson, friend, uncle, magazine, day out, crush, conversation, shopkeeper, made them that way. That, I suspect, is the best we'll ever be able to do.

The Movies

The year after their first hits, Prince and Dickens were both twenty-five, as you've probably worked out. One year after *Pickwick*, people were reading *Oliver Twist*. One year after *1999*, Prince released *Purple Rain*. The album is, at the time of writing, thirty-eight years old, and the book one hundred and eighty-five—which is, by bizarre coincidence, thirty-eight in album years, which are like dog years. Even if this last fact turns out not to be a fact at all, these are two works of art that have, to date, endured. Many of us cannot hear the words "Dearly beloved" in any context without thinking of the introduction to "Let's Go Crazy." Anyone who has ever asked for "more" of anything has, at some point, been greeted with a mock-disbelieving roar. Both *Purple Rain* and *Oliver Twist* were big hits upon their release, but they were not hits that faded

away when the initial enthusiasm wore off. They have both, as far as one can tell, become permanent cultural touchstones. Prince seems to have succeeded in copyrighting an entire color, and not one of the obscure shades, either, like coquelicot or aureolin. Purple is one of the big ones—not a primary, admittedly, but certainly one of the top ten or fifteen. "Purple Rain" was named the best song of the 1980s by *Pitchfork*, and one of the best five hundred of all time by *Rolling Stone*. "When Doves Cry" from the album finished higher up the list. The album was placed by the Library of Congress on the National Recording Registry, alongside Coltrane and Dylan and Memphis Minnie and the rest of the best music made since we discovered the ability to duplicate sound.

The garage duo Artful Dodger launched Craig David's career, and you can drink in several pubs bearing the Dickens character's name, as well as the name of the eponymous hero. In London you can also drink in the Betsey Trotwood and the Nicholas Nickleby, as well as the Dickens Inn. There is a Sam Weller's in Bath, and a Little Dorrit Park just around the corner from where the Marshalsea prison used to be. Manette Street in London changed its name from Rose Street in 1895, in honor of the doctor in *A Tale of Two Cities*. And the film historian and Kent resident Luke McKernan lists

in his wonderful blog all the businesses in Rochester, where Dickens grew up, that still mark the connection: "Tiny Tim's Tearooms, Fezziwig's, Mr Tope's, Ebenezer's, Pips of Rochester, Sweet Expectations, and the inspired A Taste of Two Cities. In days past we have had Hard Times the antique shop, and—believe it or not—the Havisham Wedding Center, which perhaps not surprisingly went out of business."*

* Robert Douglas-Fairhurst's Rochester favorite is Little Dorrit Body Piercing. I haven't reread the novel in order to find the connection, but I'm sure it must be in there somewhere.

Cold War Steve's 2020 artwork *More Sir* shows a hungry, Oliver-like child being spurned by Boris Johnson while his Tory cronies look on, smirking. You can argue all you want about whether *Purple Rain* and *Oliver Twist* are any good. I think it's very hard to argue that they are not alive.

Something that both *Purple Rain* and *Oliver Twist* have in common is that some hard-core Prince fans and Dickens devotees aren't crazy about them. Or rather, we recognize their importance and influence, their immense contribution to the stories of their creators, their popularity, their innovation, but they tend not to be our favorites. "'Purple Rain,'" said Matt Thorne in his book *Prince*, is "the first song a concert virgin wants to hear and about the last (along with 'Cream,' 'Kiss' and 'Let's Go Crazy') a concert veteran wants him to play." Speaking as someone who was both amazed and enthralled to hear Prince playing "(How Much Is) That Doggie in the Window?," I know exactly what Thorne means. When pop music reaches a certain level of ubiquity, it's hard for it to retain much in the way of juice, meaning, or mystery. We all know what we think of the Beatles. But we hear their songs constantly, without trying to, and I know I don't often *choose* to listen to them, not while there is so much else I love that hasn't had the same exposure, and so much music left for me

to hear for the first time. How many times can you hear a three-minute (or in the case of "Purple Rain," eight-minute) song? "Purple Rain" is a lot younger than "She Loves You" or "Baby Love," but it's nearly forty years old. At least the guitar solo was different each time Prince played it. *Sign o' the Times* is, both critics and many Prince fans agree, a better album than *Purple Rain*, not least because it's a double album which contains songs that you may have nearly forgotten about.

But it's not just the familiarity of the music. "Prince made most of the music for the *Purple Rain* album with the concept of the film in mind," Prince's tour manager Alan Leeds told Duane Tudahl—whose book *Prince and the Purple Rain Era Studio Sessions* is the definitive work on Prince's output during this time, and one of the most instructively detailed books about creativity I have come across. ". . . Visually, the idea of a rock icon with a guitar, posed with his legs open, has a lot more cinematic impact than a guy standing at a keyboard. So I think just the fact that this guy saw himself as a movie star making a musical, a rock musical, dictated that he made sure he gave himself the vehicles to do his guitar schtick, because it was the role, this is the imagery."

And maybe that's the thing that stops some of us

from loving it completely. If you could only choose one
Prince album from his catalog, you'd choose one that
gave the freest rein to his extraordinary gifts. The songs
on *Purple Rain* certainly allow him to cut loose with his
guitar, and I love his playing as much as anybody. ("If
Prince had only played the guitar," said a friend, "he
would be the greatest guitarist who ever lived. But he
was Prince.") There's not really any dance music on
the record, though. There's no "Housequake," or "Get
on the Boat," which is regrettable only because I love
watching Prince dance, and a lot of *Purple Rain* prevents
him from doing so—indeed, its portentousness stops
him from having much fun at all. There isn't a great
ballad there, no "Condition of the Heart" or "Some-
times It Snows in April" or "Slow Love." There's noth-
ing as cheeky and gleeful as "Delirious." And is it unfair
to say that some of the synth and drums sound very
1980s—the decade that musical taste forgot? None of
these quibbles can take away from the impact of the
record. I wish I could hear "Purple Rain" and "When
Doves Cry" for the first time again.

There is something else that *Oliver Twist* and *Purple
Rain* have in common, apart from their cultural endur-
ance and the youth of their creators: they both owe
an awful lot to the movies. Without the movie *Purple
Rain*, it's impossible to imagine the album making the

same impact. And without Lionel Bart's musical *Oli-ver!*, adapted into a smash-hit film directed by Carol Reed, there is a chance that *Oliver Twist* would not be any more famous, more representative of the author's work, than *Great Expectations* or *David Copperfield*.

Movies often transform the lives of books, of course, but it's hard to think of another album being trans-formed in this way. And it wasn't quite a soundtrack album, either. The movie came from the record, and the record came from the movie. Looking back on it now, it's hard to believe that *Purple Rain* the movie was allowed to happen. But after the success of *1999*, Prince told his management team in LA that he would only extend his contract with them if they got him a major motion picture. "It has to be with a studio—not with some drug dealer or jeweler financing. And his name has to be above the title," manager Bob Cavallo re-called in attempting to summarize the startling de-mand. Yes, Prince had broken through with *1999*, but Boy George and Culture Club had three hits that same year, one of them bigger than "Little Red Corvette," Prince's biggest to date. And try as one might, it's im-possible to imagine a big Boy George movie, despite Boy George's similarly incendiary effect on our con-ception of gender—especially a movie that took in $72 million worldwide. One thing that's clear about both of

the protagonists in this essay is that their self-confidence
was as remarkable as their talent. But we all went to see
Purple Rain, and then bought the album. Or we bought
the album and then went to see the movie. Either way,
there was some top-notch synergy going on.

Why did we see it? Why did I insist on going to a
late show on the opening night? Why didn't I seem to
notice that the performances and the script were comi-
cally inept? I was Prince's age. I used to see Scorsese
and Altman films as soon as they were released. But
then, this wasn't a movie so much as a long MTV con-
cert video containing spectacular performances, not
only by Prince but by Morris Day and the Time. Just as
my teenage friends and I had sat through the intermi-
nable on-screen conversations to get to the dirty bits of
Last Tango in Paris, so we had to sit through the fanciful
eroticism of *Purple Rain* to get to the music. Someone,
somewhere, was very smart about what was dropped
when, too. "When Doves Cry" came out in March and
spent five weeks at number one. The music video was
shown by MTV in June, the same month the album
came out. The movie was released at the end of July. By
then, Prince had, apparently through sheer force of
will, achieved ubiquity. The film even attracted the at-
tention of Pauline Kael in *The New Yorker*, who dismissed
it with perhaps the nerdiest and least comprehensible

put-down I have ever read: "As a movie, *Purple Rain* is a mawkish fictionalized bio—it's as if Lillian Roth (rather than Susan Hayward) had starred in *I'll Cry To-morrow*, or Barbara Graham (rather than Hayward) had starred in *I Want to Live!*" Yo, Pauline! It's 1984! Everyone's going to see *Ghostbusters* and *The Terminator*! She also finds it noteworthy that her own profession is being circumvented in the promotion of *Purple Rain*. "Rock critics are being quoted in the picture's praise; one suggests that it's the *Citizen Kane* of rock movies, another ranks it with *A Hard Day's Night*." In other words: wrong people, wrong opinions, although why she thinks a rock critic wouldn't review a rock film, and why that review should be discounted, remains unclear. It is, however, an early indication of how specialist critics would come to feel marginalized in the new multimedia world. "It's pretty terrible," she goes on to say. "The narrative hook is: will the damaged boy learn to love? There are no real scenes—just flashy, fractured rock-video moments." She's not wrong, but that wasn't the point.

Thomas Hardy, born less than thirty years after Dickens and a Victorian novelist (he was a twentieth-century poet, but all his novels were published before Victoria died), drove himself to Marble Arch to see a movie adaptation of *Tess of the d'Urbervilles*, a piece of literary trivia that never ceases to amaze me. Dickens

missed the age of cinema, but not by that much. If he had lived to be eighty-five, he could have seen *The Death of Nancy Sykes*, a silent short dramatization of a scene from *Oliver Twist*. And Dickens has been acknowledged as an enormous influence on early filmmakers: Eisenstein, no less, wrote an essay entitled "Dickens, Griffith, and the Film Today," which pointed out that D. W. Griffith simply transferred Dickens's narrative devices into his screenplays.

Griffith's innovation eventually became known as "cross-cutting." Before *Oliver!* the movie, there was *Oliver!* the West End (and Broadway) musical, which opened in 1960.

Lionel Bart, who wrote the music, the lyrics, and the book of the musical, remembered *Oliver Twist* from his childhood—but it wasn't a memory of the book. "When I was a young kid in the East End," he said, "there was a little sweet shop opposite our house where you could get a chocolate bar with a toffee in it for a penny. It was called 'Oliver' and the wrapper around it had a picture of a lad asking for more." Now *there's* a literary afterlife. At the time, good musicals were all American, and had been for decades. Nobody in the UK knew how to write a "book" musical, in which the songs are blended into the narrative. But Bart's credentials for turning a Dickens adaptation into a Broadway

smash were impeccable. He was the youngest of eleven children, so he knew something of the privations Dickens described, and grew up in the neighborhood where so many of Dickens's fiction takes place. He was also musically gifted, but in a popular idiom, and was already responsible for several hit records. He was ruthless with the book, too—or rather, he was happy to use David Lean's already ruthless template from the 1948 movie. The book is several hundred pages long, and the film is a polite one hour and fifty-six minutes. Dickens's characters, sense of place, and plotting made him irresistible to those who work in theater, cinema, or TV, but his adaptors have always been torn between a length that will do him justice and an evening out that can be comfortably accommodated between dinner and bedtime. Lean's *Great Expectations* was just under two hours; Christine Edzard's 1987 film of *Little Dorrit* was five hours and forty-three minutes, and had to be divided in two. Armando Iannucci's *The Personal History of David Copperfield* was also under two hours; David Edgar's famous 1980 theatrical adaptation of *The Life and Adventures of Nicholas Nickleby* was eight and a half hours, divided, like Edzard's film, into two almost digestible halves. Television serializations, perhaps unsurprisingly, are where Dickens works best, or at least, where his teeming, unruly imagination can be most

respected. The 2005 *Bleak House*, told in half-hour episodes after the one-hour introduction, is so brilliantly paced that one can imagine the breathless wait for the next number that his original readers must have felt.

Much of this ruthlessness was to do with the scything of subplots, but there was something else that proved to be important, too: Fagin became both lovable and much less problematic. In the book, Fagin's Jewishness and Dickens's use of anti-Semitic tropes and stereotypes are everywhere, impossible to ignore, and they had implications and repercussions that stretched across the centuries. Dickens apparently regretted his portrayal. A Jewish friend wrote to him, and he spent a lot of time excising references to "the Jew" from later editions; he tried to make amends with the character of Riah in *Our Mutual Friend*, whose saintliness and humility render him almost lifeless. But the problem never went away. Alec Guinness's portrayal in the 1948 Lean film was sufficiently offensive to cause cuts and delays to the US release.

But the musical Fagin was someone different—a lovable rogue with two showstopping songs: "You've Got to Pick a Pocket or Two" and "Reviewing the Situation." Bart himself was Jewish, and so was Ron Moody, the star of the original stage show and the first Jew ever to play the part. As far as one can tell, Fagin didn't

cause any offense, either in the UK or, perhaps more significantly, considering the trouble Lean's movie got into, on Broadway, where it received ten Tony nominations and ran for three years (and where Davy Jones, later of the Monkees, played the Artful Dodger). Fagin became something different, and Dickens did, too. Despite the polemicism of *Oliver Twist*, and its depiction of London's darkest and most miserable corners, the musical presented Dickens as a cheerful sort of chap, tuneful, family-friendly; on OUPblog, Marc Napolitano counts ten Dickens novels that have since received the musical theater treatment, including the unfinished *The Mystery of Edwin Drood* and the famously grim *Hard Times*, the stage adaptation of which opened and closed in the summer of 2000. "The musical *Hard Times* is a humane and hilarious insight into society played out against the wit and wizardry of the circus," says ThisIs Theatre.com. The novel *Hard Times*, it's fair to say, isn't that at all.

The movie version of Bart's musical was nominated for eleven Oscars and won six, including Best Picture and Best Director. Dickens was a hundred and fifty-six when the film was released, a little late in the day to undergo personal transformation, but Lionel Bart did something to him, just as the film *Purple Rain* did something to Prince. And, as a consequence, people got them wrong.

The Working Life

Dickens started publishing *Oliver Twist* before the serialization of *Pickwick* was over. He started publishing *Nicholas Nickleby* before he was done with *Oliver Twist*. In other words, he could keep two books alive in his head at once—two sets of characters (and, of course, the cast list in any Dickens novel is immense), two plots, two different tones. "Was he a Martian?" the novelist David Gates asks in his introduction to *David Copperfield*. No other writer has done this, as far as I know, and nor do I know of anyone remotely capable of it. And if they were, what is the likelihood that the result of this already-bizarre facility would be *Oliver Twist* and *Nicholas Nickleby*, two of the best-loved and most enduring novels in the history of literature?

It hardly needs pointing out that he did it all wrong, in every single way, if conventional twentieth- and

twenty-first-century wisdom about how to write fiction is sound. "Writing a book, full time, takes between two and ten years," says Annie Dillard, inexplicably, in her book *The Writing Life*. "My guess is that full-time writers average a book every five years: seventy-three usable pages a year, or a usable fifth of a page a day." She must have known about Dickens, for whom that "usable fifth" would have resulted in bankruptcy. She must have known that Kerouac wrote *On the Road* in three weeks. She might not have known or cared that P. G. Wodehouse, one of English literature's great stylists, wrote ninety books, forty plays, and two hundred short stories in seventy-odd years. Most of the books are read and loved today. "Cut until you can cut no more," said an established novelist in *The Guardian*'s "Ten Rules for Writing Fiction." "Reread, rewrite, reread, rewrite. If it still doesn't work, throw it away," said another. "Write for tomorrow, not for today," said a third. "Proceed slowly and take care," said a fourth. Dickens, one must presume, given his schedule, did none of these things. *David Copperfield*, David Gates wrote, is "a novel any writer could still learn from, and should still be intimidated by. It would be scary enough if he'd put it through years of rewrites: in fact, he wrote it as he did all his novels, by the seat of his pants for serial publication."

Combined, *Oliver Twist* and *Nicholas Nickleby* run to about half a million words, roughly two *Moby Dick*s, or all four of Elena Ferrante's Neapolitan novels. He started publishing *Oliver Twist* in February 1837, and finished it in April 1839; the last episode of *Nicholas Nickleby* was published in October of the same year. So these half-million words were written in thirty months, with a particular flurry in the year preceding the final installment of *Oliver Twist*, when he was writing both at once.

Some of the lessons to be learned from Dickens's astonishing accomplishments are antithetical—for writers, anyway. We should, as Gates says, be intimidated by them—or at least, we should if that's what we're aiming for. (The better way, I think, is to conclude that it's not worth bothering, even if you've been published, even if you have sold well, and/or won prizes. You can't get there.) But alongside the intimidation, there's something very liberating about his method of working, because it immediately explodes the idea that there is a right way of doing things. If arguably the greatest novelist in the English language wrote for today and not tomorrow, and proceeded quickly and without much care, then maybe the advice that other writers dispense isn't worth tuppence. And maybe it's just me, but

the fecundity of his imagination, the immediate access he has to narrative ideas (ideas which came "ready made to the point of the pen," he said to a young writer*), words, characters, all just below the surface in an apparently inexhaustible reservoir of bubbling creativity, is refreshing and inspiring, too. Every time someone tells us that creativity is hard, rare, precious, inaccessible, or needs treating with suspicion, just remember the twenty-five-year-old who could write two massive, brilliant novels at once. He was the Inimitable, I know, but contemplating the apparent ease of his inimitability can't help but loosen one up.

Dickens wasn't a perfectionist. He didn't have the time. It's hard to know what goes on with the writers who disappear for ten or fifteen years between books, or who never write again after a notable success. Salinger apparently wrote a whole ton of novels after *The Catcher in the Rye* but published nothing at all after a *New Yorker* short story in 1965, when he was forty-six, presumably because he had been spooked by his enormous success. Casey Cep's fascinating book *Furious Hours* describes how Harper Lee looked to follow up *To Kill a Mockingbird* with a true-crime book similar to her friend

* The young writer was G. H. Lewes, later to become the partner of George Eliot.

Truman Capote's *In Cold Blood*, but nothing came of it, or of anything else. Harold Brodkey took twenty-seven years to finish *The Runaway Soul*, which had achieved near-mythical status by the time it came out in 1991. "*The Runaway Soul* is absolutely the last book you want to say this about, but it could have used a rewrite," was the verdict of the *Newsweek* reviewer. At the time of writing, it is out of print. Were Brodkey, Lee, and Salinger perfectionists? If so, they don't have much to show for it.

"The fact is, Mr Dickens writes too often, and too fast," said a famous, anonymous, and much-quoted contemporary review of Dickens's early works in *The Quarterly Review*. "If he persists much longer in this course, it requires no gift of prophecy to foretell his fate—he has risen like a rocket, and he will come down like the stick." The review was not quite as harsh as these lines make it seem; the reviewer was on Dickens's side, and wanted him to preserve his talent. Even so it was wrong. The books were read and loved, and they have endured. There isn't much to it, apart from that, is there? Too often and too fast for whom?

Dickens was not, from the sound of it, a man short on self-confidence, but there is a certain humility in continuing to bash books out. It's the mark of a writer who sees himself as an entertainer, with a duty to his public—and of a breadwinner, with a constantly grow-

ing young family. (His tenth child was born in 1852, when he was forty.) This is not dissimilar to the way the other greatest writer in English history saw himself. In 1599, Shakespeare wrote *Henry V, Julius Caesar,* and *As You Like It*. Oh, and *Hamlet*. In the twentieth or twenty-first century, the creation of any one of those might have resulted in a great deal of self-consciousness and second-guessing. *Jesus Christ, how the hell do I follow up* Hamlet.? But Shakespeare had a theater company to pay for. The players in the Lord Chamberlain's Men needed product, much more than a fifth of a usable page a day, and Shakespeare had to provide it. Only a fool would argue that great literature is only produced quickly, and through financial necessity. But the opposite argument—that great literature is only produced slowly, and with no consideration for money—is even madder. The truth is that nobody knows anything. All we can say for sure is that great books and great plays come from people of any background, and of any age, in any circumstance.

PRINCE WAS WORKING on several projects at once while he was recording *Purple Rain* in 1983 and 1984. You could argue that music is music, and that therefore

recording can't be compared to novel-writing—Prince didn't have to keep themes, plots, characters apart. But what he was attempting to do was still pretty complicated. He needed, or at least wanted, three different albums to accompany the movie of *Purple Rain*. There was the *Purple Rain* album, the songs of which were shaping, and being shaped by, the script for the movie. He wanted a new album by the Time, the group led by Morris Day, who plays the Kid's archrival in the film, and an album from Apollonia 6, a sort of group, sort of fronted by Apollonia, who plays the Kid's love interest. Everything would help promote the movie, but only if he was controlling it all. (The Time was a functioning, independent band until they were cast, at which point Prince started dictating both product and personnel.) And then there was the album he was making with/for Sheila E., his percussionist and friend, and the album he was making for the Family, a band which was formed out of the musicians he saw regularly in the studio—sax player Eric Leeds said the Family album was "as much of a Prince album as anything he's ever done." Buried on the Family album was the song "Nothing Compares 2 U," later redeemed and repurposed. He wrote and recorded "Sugar Walls" with Sheena Easton. (Genuine Google search suggestion:

"Are Sheila E. and Sheena Easton the same person?")
He wrote "Manic Monday" for Apollonia 6, but clearly
had second thoughts about their commercial potential.
And he was already at work on his own *Around the World
in a Day*, a very different-sounding collection of songs,
influenced by the world music that Lisa Coleman's
brother David had introduced him to. According to
PrinceVault.com (and believe me, they know) there
were one hundred and eight tracks recorded in those
two years, all of them requiring his involvement in
some key capacity. Many of them were eventually re-
leased under his name, as B-sides, and then on the
expanded 2015 *Purple Rain* album, which contained
eleven songs previously only available on bootlegs.

Of course, not everything is up there with "When
Doves Cry," or "Purple Rain," or "Nothing Compares
2 U," but most of the tracks were at least worth record-
ing. Sheila E.'s album turned out nicely, "Sugar Walls"
was a hit, the Time album eventually certified plati-
num. And there are unquestionably hidden gems in
the things he recorded and didn't do much with. "She's
Always in My Hair," recorded alone in the studio over
a day with Prince playing drums, bass, guitar, and
synths, would have made it onto anyone else's album
for the guitar solo alone. "17 Days" is a furiously pro-
pulsive piece of funk with a supercharged ska tinge.

But whether it was best Prince or average Prince, that wasn't the point. The point was that he had to do it. "According to many people who've spent time with Prince, he was addicted to the creative process," says Duane Tudahl. "He was constantly looking for something that wasn't familiar to keep him interested."

"He was not a perfectionist," said Prince's engineer Susan Rogers. "He wouldn't have had that output if he'd been a perfectionist . . . It just poured out of him— he couldn't wait on perfection." "Prince taught us perfection is in spontaneity," said Terry Lewis, who was fired from the Time by Prince, but who, with Jimmy Jam, went on to have an enormous career in production and songwriting. "You just do it, and whatever it is, it's perfect! Create, and don't ponder what you created."

In 1986, Prince built a studio, a proper one, in his home in Minnesota. The need for an expensive studio was an indication of both creative superabundance and, paradoxically, a lack of interest in perfection. A little four-track would have meant he was making demos, and he didn't want to do that. Demos were for laggards, for people who spend a long time making an album. Prince wanted to roll out of bed and know that whatever he recorded that day would be good *enough*, and then he could move on. He wanted to create, and not ponder.

Susan Rogers oversaw the installation of the console, and the very first track that Prince recorded on it was "The Ballad of Dorothy Parker," one of the tracks on *Sign o' the Times*; to her horror, that first recording didn't sound good. "It sounded like there was just a blanket over everything," she recalled, "with each instrument we're adding . . . I'm going to be in more and more trouble, because it's not just ruining the drums; it's ruining the drums and the bass and the keyboards and the vocals. But . . . I knew him pretty well at this point. Don't stop him. Don't stop him. He's on a roll, he's happy. Let him go and fix it later." But he never did fix it. "He didn't care," said Rogers. "It was one of those happy accidents where the lack of high end, the dullness, made it sound underwater. He used that dull response to make art."

I wouldn't want my first drafts published or filmed. Prince and Dickens were lucky in that they didn't *need* to be any better than they were. If you're capable of knocking out *Purple Rain* and *Oliver Twist*, what would be the point of delaying the process by a couple of years to make them slightly better, or focusing on one project at a time? That way we'd have lost something further down the line—a novel, an album, a few side projects. There would have been less, and in this case, less is not more. We'd have lost out. And of course "The Ballad of

Dorothy Parker" sounds great underwater. The rest of us, though, would have sounded like we were drowning.

"Perfectionism is the voice of the oppressor, the enemy of the people," said Anne Lamott in *Bird by Bird*, her book about writing. "It will keep you cramped and insane your whole life . . ." But it's not a choice, really. I am sure that whatever stopped Harper Lee from writing a second book, she'd have preferred the impediment not to be there. And Salinger, in that pitiful late snatched late-snatched photograph, didn't look like a man who was enjoying his royalty checks and a few rounds of golf. Nor could the problem have been resolved by stern self-admonishment and a determination to let things go next time around. Any perfectionist needs to stop being who they are, and that's hard.

I understand Prince and Dickens better than I understand the perfectionists. Since I started writing professionally, there has always been something I want to get on with which is not the thing I am working on; I was thinking about the book you're reading now while in the middle of something else, and now that I have started this book, I am also thinking about the next thing. This speaks more of someone with a short attention span than it does of genius, sadly, but it does also mean that more things get done. I started my writing career at thirty-five, and I have always had a sense that

my creativity was blocked in the years leading up to it. I have been making up for lost time. Whenever one of my novels has been optioned for the screen, I have never wanted to do the adaptation myself. A book takes a couple of years, and there are often four or five years between publication and production; I don't want to, can't, think about the same material for six years.

A strange by-product of working in movies and TV, however, is that perfectionism is forced upon you, by cast and directors and producers. By "perfectionism" I don't mean the act of making things objectively perfect, by the way. Perfectionism here means the act of doing things over and over again until you're sick of them. Notes are given by various people at various stages of the process, usually about every single line in the screenplay, so that things which might have been left untouched in a novel—because there are no actors, there are no budgetary considerations, there is no director's vision—are subject to scrutiny and amendment. With a novel, there is you, and there is an editor, who is trying to find the best version of you. During the production process of a movie, you start to feel like a perfectionist, even though your non-perfectionist self is being dragged kicking and screaming back to your Final Draft document. A director's job, by definition, is perfectionist. Whenever I hear Stephen Frears shout,

"One more!" as I have done many times in my life now, I marvel at his tenacity. I couldn't be a director because I have no interest in the two-shot, or the reverse; I don't think I would ever have any real concerns if an actor delivered a line eccentrically, or if a word was muffled. That'll do. Let's move on. But you can't work like that, because the results would be unwatchable, and that's the same whether you're trying to make a comic-book movie or an Oscar-ambitious adaptation of a literary novel. Despite the oft-repeated claim that Dickens had a cinematic or televisual imagination, he would, I'm sure, have hated the process. The next movie that Prince made after *Purple Rain* was *Under the Cherry Moon* (1986), a commercial and critical disaster. Prince fired the director and did it himself. Perhaps she was too slow. It doesn't look to me from this distance that directing was the right job for him.

HE WAS, it goes without saying, making several different albums at the same time in 1986, when he was recording all those songs on the *Sign o' the Times* boxed set. One of them was for a female alter ego he called Camille, whose androgynous voice was created by changing the pitch on his vocals—the song "If I Was Your Girlfriend" on the original album is perhaps the

most notable demonstration of his intention. There was another album called *Dream Factory*, which, like the *Camille* album, became folded into the triple album *Crystal Ball*, which became the original double album *Sign o' the Times*. The triple album *Crystal Ball*, by the way, is not the same as the triple album also entitled *Crystal Ball*, which came out in 1998 and which comes after the triple album *Emancipation* in his discography. That's an awful lot of music. The sixteen tracks on the original album don't really cohere into a unified whole, but that's the glory of it; even now it's possible to come across a great song that you've forgotten about because it somehow doesn't seem to belong. And that way, Prince is given permission to display the full range of his talents. *Sign o' the Times* isn't a funk-jam album, or a robotic electro-pop album, or a Jehovah's Witness album (there was one of those). It was all of these things and more. For me, *Sign o' the Times* is right up there with the great double albums, with *Blonde on Blonde*, *Exile on Main St.*, *Songs in the Key of Life*, and *London Calling*, and is probably the only one of even that august group that I would happily listen to from beginning to end right now. It was, after *1999*, his second great double album in five years.

Prince was twenty-eight when he was recording

Sign o' the Times. Dickens was working every bit as hard at the same age, but not because he was on fire, like Prince. On the contrary, he was worried that the embers of his creativity were cooling too fast. He had written three big novels and a couple of plays, and was the editor of a monthly magazine. He had a young family and was living beyond his means, and as a result he had gotten into a mess by promising different publishers work he couldn't possibly deliver. In 1840, says Claire Tomalin, "he intended to enjoy himself in a more leisurely way by editing *Master Humphrey's Clock,* the small miscellaneous weekly magazine." It would be filled by his literary friends, and, he hoped, would pay him £5,000 a year while he recuperated. But after a promising start, sales of *Master Humphrey* crashed, and as far as he could see, the only way out was to turn a short story he had written into another full-length serial—which meant he had to improvise week to week a novel he had not even thought of in January. I'm sure it would come as a relief to creative writing professors, or serious-minded literary aspirants, if I were able to tell them that the name of this novel was *Christopher Christian,* or *A Word in Your Ear,* or something else that has been forgotten and out of print for a hundred and eighty-odd years. Unfortunately, it was *The Old*

Curiosity Shop. Little Nell, Quilp, and Dick Swiveller were invented more or less on the spot, to dig the inventor out of a financial hole.*

In the end, it doesn't matter how Dickens arrived at his creativity. Once he had determined to write a book, it didn't have to be dragged out of him, word by torturous word. The only pain he caused himself by the writing of *The Old Curiosity Shop* (if one disregards the toll it took on his health) was the death of Little Nell. "All night I have been pursued by the child; and this morning I am unrefreshed and miserable," he wrote to his friend Forster. "I am breaking my heart over this story, and cannot bear to finish it," he said to his illustrator. Nell's demise became one of the best-known in the history of literature, although as A. N. Wilson points out, Dickens was especially good at creating memorable deaths for both major and minor characters. This odd talent eventually came to represent just about everything good and bad in Dickens, and Victorian England. It is and was, variously, depending on who you listen to, an indictment of Dickens's sentimentality, or his power to connect with the masses in the way that

* The same thing happened with *Great Expectations*, which was written when Dickens realized that the novel he was attempting to serialize, Charles Lever's *A Day's Ride*, was a turkey.

only television has done since; it even gave rise to an urban myth. There never really was a crowd of thousands at the harbor in New York desperate for news of Little Nell's health. Carra Glatt, in a gratifyingly exhaustive article for *Nineteenth Century Studies*, dispels the rumor, pointing out that one could never predict the arrival of ships back then. They might be a few days early or a few days late, and it would take a particularly nutty kind of Dickens nut to wait around for a week or so. Plus, Dickens had signed deals with American publishers, which enabled them to print the serials themselves. Glatt can trace the urban myth of the harbor crowds only as far back as 1940, when a newspaper columnist called Channing Pollock included it, or very possibly invented it, to illustrate his point that, back in the day, Americans used to value worthy and morally uplifting fiction. (Dickens, by the way, may have been surprised to learn that he wrote worthy fiction.) Shortly thereafter, it began to appear in Dickens biographies.* In a way, the myth of Little Nell's death and the docks is even more remarkable when we consider

* In Stephen King's introduction to *The Green Mile*, which, like *The Old Curiosity Shop*, was published in installments, New York has become Baltimore, and several Dickens fanatics were jostled into the water and drowned. Watch out with those serialized novels. They turn people savage.

the circumstances in which Little Nell was born. Dickens was worried about his magazine collapsing, so he whistled up a novel on the spot, and a hundred years later people are making up crap about stampeding mobs desperate for the next installment.

Queen Victoria read it and pronounced it "cleverly written." (Whether she was the last member of the royal family to read a Dickens novel, or any other work of literary fiction, is a question beyond the remit of this book.) It was Dickens's second most popular novel in his lifetime. Dick Swiveller, with his languid, comical phrasemaking (alcohol is "the rosy," one drink is a "modest quencher," a piece of bad news is a "staggerer"), is so clearly an influence on Wodehouse that Bertie Wooster would have been entitled to a DNA test. So much came from *The Old Curiosity Shop* that one wonders what Dickens might have achieved if he'd planned it, or even thought about it for a few weeks. Perhaps it would have made no difference, although it's hard to find anyone for whom the novel is a particular favorite, and the other one written during the *Master Humphrey's Clock* panic, *Barnaby Rudge*, is even less popular. It was his lowest seller, and is his least-read novel today. He would go on to write much better and better-loved books, so it didn't indicate any kind of decline in his fortunes or his powers.

And *Sign o' the Times*, despite its complicated gene-
sis in a period of bewildering over-productivity, was
Prince's high-water mark. Money and business weren't
affecting either of them creatively. But there would
come a time when they became consumed by both.

The Business

This week, I received a payment that I hadn't expected, or counted on. It was a small check for the repeat of the Swiss radio version of the first season of my TV show *State of the Union*. I was paid for the TV show, of course, although it wasn't commissioned, so there was no money up-front: I wrote it for nothing, in the hope of interest from producers, and then actors and a director, and then broadcasters. The writer, producers, director, and actors ended up co-owning the series, and so we have divided up equally all money subsequently received five ways (two actors, a director, a production company, and a writer). From the artists' point of view, what's not to like? We all took a risk and worked for free, but since then we have been decently rewarded, financially, and we all won Emmys. We probably didn't take as big a risk as AMC/Sundance,

the American broadcasters who literally paid for it, unless you take the view that working for free is more painful than shelling out actual money. And though nobody earned millions, I don't think any of us regrets the time or the commitment. I have taken that kind of risk before—the first draft of the film *An Education*, maybe the first couple of drafts, were written at my own expense, as it were—and I have mostly never regretted it. I was writing something I wanted to write, and had faith in, and, given I had other income coming in from my day job as a novelist, it didn't feel as though I were gambling my life away.

How is one supposed to judge whether one is being paid fairly, when you work in the arts? It has always seemed amazing to me that I have been able to support a family by making stuff up. I am glad to be paid well by my publishers, of course I am. But when it comes to the Swiss radio repeat fee for *State of the Union* it's impossible not to look on it as free money, somehow unearned. And yet it's my work. I made up the story and the characters. If someone, somewhere down the line, is going to make a profit from it somehow, then I suppose it's only fair that I share in that profit.

Here's another thing about *State of the Union*: at the time, it didn't feel like work. It was fun to write. It came quickly, probably in three working weeks, if I added

the bits of time together. And yet I'm getting the Swiss-repeat radio money two or three years after I wrote it. Maybe I'm forgetting the bits where it did feel like work—when we took a couple of wrong turns with the casting, when the brilliant and exacting actors and director had their say.* And yes, I know I am in the top 1 percent of earners in my profession, but I'm still entitled to ponder the economics of my situation.

Prince and Dickens, despite being in the top 0.1 percent of their profession, both felt that they were being robbed, and, unlike a lot of artists, they attempted to do something about it. In Prince's case, he metaphorically destroyed himself because he was so angry.

Prince's dissatisfactions seem to have crystallized in the early nineties. "You reach a point . . . where Madonna and Michael Jackson have signed very, very big deals with their record companies," said Joe Levy, then editor of *Billboard*, in a 2014 documentary called *Slave Trade*, about Prince's beef with the record industry. "Thirty-million-dollar deals, sixty-million-dollar deals. And Prince is angry. Because Prince sees

* Me, arriving on set during a rehearsal one day: "What are you doing?" Stephen Frears: "The new scene you wrote yesterday." Me: "How's it going?" SF: "Terrible. It's *unspeakable*." Maybe the Swiss radio money is karmic, in some way.

himself as a greater artist than Madonna or Michael Jackson."

This is a crucial moment in the life of any artist. The arts are unarguably subjective: lots of us spend too much of our lives arguing that she is a better writer than him, or that this band's body of work in the 1970s was better than that band's in the 1980s. Sales don't help decide anything—Mariah Carey isn't better than the Rolling Stones, whatever *Billboard* says, unless, of course, you think she is, in which case you're entitled to your opinion. Prizes don't help, either. Your favorite film of the last fifty years almost certainly didn't win an Oscar or the Palme d'Or. So what do you do when you think you're being taken for granted? The answer to the question is best solved in therapy; but if you don't have the time, or you haven't thought about the question properly, then huge advances help.

The truth is that nobody can stay hot forever. All one can hope for is that one's talent lasts for an entire career in a way that makes some commercial sense to the people who pay for it. That's the whole thing. That's the prize: a lifetime spent doing what you want to do. If you start looking around to see who's doing better than you, you are going to cause trouble for yourself, because even when you're king or queen of the world, soon enough someone else will be. The least

attractive older artists are those who can't stop whining about how they're not being marketed properly, or about how everything new is awful. They threaten to quit, or to move somewhere that appreciates them more. "An artist reaches a point in their career where they're only relevant to their die-hard fan base," said the sagacious Alan Leeds, Prince's tour manager and the president of his record label, in the *Slave Trade* documentary. "The fact that the record didn't sell through the roof isn't necessarily a statement that the record wasn't good enough or wasn't promoted properly."

Prince, it seemed, had the kind of trouble that comes when you are no longer the biggest and most important artist in the world, merely a super-talented and beloved one. He was undergoing mixed fortunes at the time he was looking for his enormous payday. His 1988 album *Lovesexy* was his least successful since the early days; the *Batman* soundtrack was huge; *Graffiti Bridge* did so-so, though the accompanying movie, like *Under the Cherry Moon*, bombed; *Diamonds and Pearls* nudged him back on track, with a couple of hit singles and pretty good album sales. And that was the moment he chose to play hardball with Warner Bros., his record company. He wanted the $100 million deal that would prove to the world and to himself that he was better than his peers, and he got it. Or at least, he got a contract which men-

tioned that figure, and which allowed the media to announce that figure in their reports of the deal. In reality, it was structured in such a way that he would never see anything like that sum, because he was no longer selling anything like the numbers he had done in the eighties, and those numbers were what the $100 million rested on. He needed to sell five million albums ten times in a row to get it all, and *Diamonds and Pearls* had just squeaked over the line. When he realized that he didn't own his own music, couldn't continue to release his friends' (frequently girlfriends') albums through his own label at the record company's expense, couldn't release seventy-song albums or three albums a year, he embarked on a battle with Warner Bros. and the music business that went on for years.

He dropped the name that had made him famous and became an unpronounceable symbol that he had no word for. ("One day maybe I'll hear a sound that will best give me the feeling of what it's supposed to be. But for right now I just go by the look of it," he explained helpfully.) He wrote the word "SLAVE" on his cheek. He released records on the internet long before anyone else was doing that. He gave Warner Bros. suspiciously substandard recordings. He refused to speak in public, and frequently covered his entire face with fabric during (silent) TV interviews. He tried to sue fan sites, at a

time when fans were slipping through his fingers like sand. He wouldn't play his hits live. As far as the majority of the public was concerned, one moment he was nine-figure rich, the next he was complaining about servitude. It was confusing, alienating, and a little tasteless, given the connotations of the word scrawled on his face. And for those of us who had started loving him in our twenties and were now in our thirties, it all seemed a little embarrassing. Nearly everybody who had any time for him lost sight of him during this period. There were countless albums, and it was impossible to tell whether they were any good or not, because nobody seemed to write about them or talk about them, although with the benefit of hindsight, Spotify, and You-Tube, it turned out that they mostly weren't.

But in one way, the way that seemed to matter to him at the time, it worked, eventually and unpredictably. Selling music direct to the public meant that he made more money on some of the more successful releases than he could have done before, and eventually he found out what the rest of his colleagues discovered much later in the digital revolution: that the only money to be made was in live shows. He made peace with his past, threw the mask away, and reminded people what a breathtaking performer he was, first with a spectacular spot at the Grammys co-starring Beyoncé, and then,

in 2007, with the greatest halftime Super Bowl show in history. That same year he played twenty-one nights at the twenty-thousand-capacity O2 Arena in London: seeing Prince live became something that nearly half a million Londoners did that summer. He had worked out that, contrary to everything that everyone in the music business continued to believe until years later, albums were there to promote shows, and not the other way around, so it didn't matter if you gave them away. After flirting with bankruptcy at the end of the nineties, Prince became rich again.

There is something rather Elvis-like about this story. There is no doubt that Colonel Tom Parker knew what he was doing, when it came to maximizing the profits of his client. Every serious student of popular music regrets Parker's decisions and choices. We are all convinced that if we had been managing and producing Elvis, we'd have got fifteen more great albums out of him between the early 1960s and his death. Whether we'd also have turned him into someone who made relevant records that connected with an audience, we will never know. Prince became consumed by the business. He hated not owning his own recordings, he hated being told that he owed money to record companies who were profiting from him. He took on the system and

eventually defeated it, and it was an exhausting, time-consuming struggle. How one wishes he had shrugged, downsized if necessary, and made great music. Maybe he couldn't any longer; maybe the muse was no longer there, but that seems unlikely. If you can be bothered to trawl through the twenty-five-odd albums he released since *Diamonds and Pearls*, you will find hidden some of the greatest music he ever made, which means some of the greatest music ever made. If you had heard "Sticky Like Glue," or "Prettyman," or "Chelsea Rodgers" on the radio at various points in the twenty-first century, and the DJ had told you afterward that it was by a new artiste, you'd have sat up and taken notice. But in the end, we stopped listening. We always stop listening. There are too many other people to hear.

CHARLES DICKENS FOUND cause to be aggrieved about the business from pretty much the time he began to publish his first book. His two main antagonists, entrepreneur and publisher Edward Lloyd, and dramaturge and producer Edward Stirling, were men whom Dickens believed to be plagiarists. Lloyd published *The Penny Pickwick*, *Oliver Twiss* (edited by "Bos"), *Nickelas Nickleberry*, and *Martin Guzzlewit* as soon as the ink dried

on the original versions, although he had to work hard for it. *Oliver Twiss*, for example, was longer than the original, and though Lloyd followed the plot of *Twist*, he would have fallen foul of copyright law if he'd actually lifted anything wholesale. If Lloyd did not have Dickens's facility for character, plot, and language—and who did?—you could even argue that he might have had to work harder than the original author.

Dickens and his publishers Chapman & Hall took Lloyd to court to seek an injunction against the "fraudulent imitation" of the books. It's hard to imagine anyone being bothered much in the present day: a ten-second Google search will lead you to books about Barry Trotter and Harry Putter and Henry Potty and Hairy Pothead. (I have made none of those names up, by the way.) But *Oliver Twiss* wasn't a parody, and it was cheaper than *Oliver Twist*, and the author of the latter was a relatively recent phenomenon at the time. Many readers were getting their first taste of Dickens through Lloyd's versions, so there's no doubt that Lloyd was costing Dickens money. Older readers may remember the albums of cheap sound-alike alternatives to chart hits that you could buy in Woolworths for something like 99p, although even then, presumably, the songwriters were getting royalties—that's the sort of thing Lloyd was doing, except he wasn't paying the author anything. The record label most closely associated with the sound-alike hits, by the way, was Pickwick. (It's just *weird* that nobody has written a book comparing Prince and Dickens before.) And, just as the Pickwick albums were considerably cheaper than the original songs, Lloyd's serializations were much cheaper than those of Dickens's novels. *The Penny Pickwick* cost a penny; *The Pickwick Papers* cost a shilling.

Dickens's court case got nowhere, but his sense of

grievance never went away, and it leaked into the books. *The Pickwick Papers* is dedicated to MP Sir Thomas Noon Talfourd, who took up the copyright cause in Parliament, and was the basis for lovable Tommy Traddles in *David Copperfield*; Nicholas Nickleby gives a "literary gentleman" not unlike Edward Lloyd a piece of his mind:

> You take the uncompleted books of living authors, fresh from their hands, wet from the press, cut, hack and carve them . . . all this without permission, and against his will; and then, to crown the whole proceeding, publish in some mean pamphlet, an unmeaning farrago of garbled extracts from his work, to which your name as author, with the honorable distinction annexed, of having perpetrated a hundred other outrages of the same description. Now, show me the distinction between such pilfering as this, and picking a man's pocket in the street: unless, indeed, it be, that the legislature has a regard for pocket-handkerchiefs, and leaves men's brains, except when they are knocked out by violence, to take care of themselves.

One of the advantages of serialization, clearly, is that you could engage in running battles with oppo-

nents in the middle of novels. Lloyd (or rather "Bos")
hit back in the preface to volume 1 of *The Penny Pick-*
wick, a collection of his first few installments, thus:

> Upon the appearance of those shilling Publica-
> tions which have been productive of so much
> mirth and amusement, it occurred to us that,
> while the wealthier classes had their Momus, the
> poor man should not be debarred from possess-
> ing to himself as lively a source of entertainment
> and at a price consistent with his means; we
> therefore took upon ourselves that arduous but
> cheerful task, and, at an immense risk, sent forth
> our little volume to the Public.

Lloyd was a shrewd operator with a twentieth-
century head for stunts and promotion. This is a man
who paid his employees with coins on which he'd had
stamped an advertisement for one of his newspapers, an
outrageous gimmick that earned him an admonishment
from *The Times*. His little dig at Dickens must have
stung. Lloyd was slyly accusing the writer with the pop-
ular touch of ignoring his working-class readers—and
Dickens himself had been as poor as any of them. "Be-
cause of his background of poverty, Dickens was al-
ways obsessed with money and realized he was being

ripped off left, right and center," said Professor Rohan McWilliam of Anglia Ruskin University, who has co-edited a book about Lloyd and his influence on nineteenth-century popular culture. That, of course, was precisely Prince's conviction too, a conviction that was perhaps rooted in similarly stony childhood ground.

Eventually Lloyd got out of the knock-off-books game and became a press baron, and there is a suggestion that he might have been embarrassed by his earlier shoddy behavior. The crimes against Dickens continued, though. As soon as the novels appeared, they were dramatized across Britain—and as they were appearing in parts, those dramatizing them had to be extremely creative with the endings, and, frequently, with the middles, too. There were twenty-six different theatrical adaptations of *The Pickwick Papers* doing the rounds by the end of 1838, and Dickens didn't earn a penny from any of them, because he hadn't written them himself. Edward Stirling, the Bluebeard of the literary pirates, was first off the starting block, staging *The Pickwick Papers, or The Age in Which We Live* when only twelve of the twenty parts of the book had appeared. The plays were everywhere—there were an estimated sixty productions of the first three novels. One twentieth-century critic described them as the "Boz Cascade" and the "Dickens deluge." Everywhere the

author looked, it seemed, people were profiting from his name. The plays drove Dickens mad, especially when people were watching them before the books were finished. Being "badly done and worse acted," he said, they "tend to vulgarize the characters, to destroy or weaken . . . the impressions I have endeavored to create, and consequently to lessen the after-interest in their progress."

If the theatrical piracy was, in some ways, simply the way popular culture worked back then, to modern eyes the American publication of his books was much closer to straightforward theft. They were printed without Dickens's permission, and they were enormously successful, and it was a very satisfactory arrangement as far as the American publishers were concerned—so satisfactory that they were outraged by Dickens's argument that there was something vaguely illegitimate about it. One of the publishers did offer him $25, "not as a compensation, but as a memento," but Dickens, understandably, seems to have been unimpressed, and continued his battle.

And it wasn't just the publishers who were outraged. When Dickens spoke publicly in America about copyright and intellectual theft—and he was a bestselling author, so there were huge crowds everywhere—the press turned on him, too. "You must drop that, Charlie, or you will be dished," said one Boston paper. "It smells

of the shop—rank." "It happens that we want no advice on this matter, and it will be better for Mr. Dickens if he refrains from introducing the matter hereafter," said *The Hartford Times*. He was described variously as "a mere mercenary scoundrel," "no gentleman," and "no better than John C. Colt," the brother of Samuel, who had recently killed a printer with an ax. This last accusation seemed particularly unfair. Colt owed the printer money, not vice versa, and Dickens had not killed anyone with an ax or any other weapon. He had merely suggested that authors should be paid for their work. Surely that made him *slightly* better than John Colt? Apparently not. When Dickens tried to argue that fair compensation would assist in the creation of an American literature, the answer was blunt: "We don't want one. Why should we pay for one when we can get it for nothing? Our people don't think of poetry, sir. Dollars, banks, and cotton are *our* books."

There was one American court case involving Dickens in his lifetime, *Shelton v. Houghton* in 1865. The warring parties had once been partners: they had joined forces to publish a uniform edition of Dickens's work. When the partnership came to an end, they sued each other for the rights to carry on publishing the book. It goes without saying that Dickens himself was not involved in the argument.

Soon after that, Dickens went back to America for the last time in his life. In an odd prefiguring of the lesson that Prince learned, Dickens performed a lucrative reading tour of the Northeast states, seventy-six dates in five months. He had worked out, in England, that live appearances earned him more than his books, and so he developed a stage show. He didn't read directly from the novels; rather, he mined them for dramatic scenes, then condensed and adapted, "with the emphasis always on pathos and humor," as Claire Tomalin puts it. He performed his greatest hits, selections from *A Christmas Carol*—over half the readings consisted of Christmas stories—*David Copperfield*, *Pickwick*. He was, by all accounts, a magnificent live performer, and a popular one. "It is impossible to get tickets," Henry James wrote to his brother. "At 7 o'clock am on the first day of the sale there were two or three hundred at the office, and at 9, when I strolled up, nearly a thousand." Dickens earned the contemporary equivalent of £1 million. He hadn't quite stuck his work on the cover of a newspaper, but all those pirated books had created a huge fan base.

THE FEELING THAT he was being robbed might not have driven Dickens potty, as it did Prince. There were

no masks, name changes, attempts at self-sabotage. But it did make him very unhappy. Or rather, the attacks he endured in the American press made him very unhappy. "I vow to Heaven that the scorn and indignation I have felt under this unmanly and ungenerous treatment has to me been an amount of agony such as I never experienced since my birth," he said to an American friend.

"That was a lot of days of us coming to rehearse and him being furious after just talking to Warner Bros. on the phone," Prince's drummer Michael Bland told David Browne of *Rolling Stone*. "And instead of rehearsing, he spends two hours venting to us about what's going on. He was so distraught. It just sent him into a tailspin. Day to day, we didn't know what we were walking into coming into rehearsal." Yet Prince loved to play, to record and perform and make music, above all other things.

One might at this point ask the question, of both Prince and Dickens, "Why not just be happy? Things are going great. You are one of the most successful people in your field. You're world-famous. There's plenty of money. There will be more. Chill." They were both complicated people, and therefore though one can provide some simple answers to the question, maybe the root cause is buried somewhere deep in their child-

hoods. Here is one of the simple answers: artists have a freelance mentality. There is always a fear of failure, a sense that the next book or record will not only fail, but somehow render all the others unreadable or unlisten- able. Tastes change. People have their moment in the sun, and then the sun moves on to somebody else. Our careers seem built on nothing—words, ideas, sand— and we can all too easily imagine the plummet back down to earth in a way that doesn't seem possible if you're a lawyer, or if you have a skill you know people are going to need tomorrow, next year, the rest of your working life, like plumbing or dentistry. There are al- ready plenty of books and music, paintings and movies. People could cope without more. They might even wel- come the break in the flow.

Here's another one: Prince and Dickens both earned a lot, but they had a lot of commitments, too. Paisley Park, Prince's private estate, with its studios and its soundstage, its wardrobe department and its vegan chef, cost him $2.5 million a month, according to Randy Phillips, his former manager. He had an un- showy philanthropic side, too. Tax returns show that he gave away $1.5 million between 2005 and 2007. (Over half of that went to the Jehovah's Witnesses, but whatever. It all counts.) Dickens had his ten children, a mistress and her family as well as a wife, and a feckless

father who always needed bailing out. His brothers could never support themselves. He had orphaned nieces and nephews. His sons were hopeless, and his sister-in-law looked after his household after his marital separation. He gave money to friends, and dependents of friends, and supported over forty different charities, with time or work or straightforward gifts of money.

And both of them, it must be said, helped future generations of artists by asking the questions they asked. We think the behavior of Dickens's American publishers is eccentric and outrageous because he helped to make us see it that way, and eventually something was done about it.

Only a certain kind of artist is consumed by the feeling that they're being cheated, however, unless there is an actual crook involved. We can sort of see now that Dickens was being fleeced by the Americans and the plays and the knock-off books, but they were cultural norms; Prince was mostly angry with the music business for doing what all entertainment businesses have always done, namely, make more money than the artists they're selling to the public. He was also angry that he couldn't release as much of his music as he wanted whenever he wanted, but that *was* mad. He'd been in the business long enough to know that promoting a record properly needs time and thought and dis-

tribution, and money. And yes, it turned out that he'd been conned by the $100 million deal—but he had played his own part in that.

I know that I have been the victim of piracy, in very small ways. Friends have come back from some exotic holiday in the Far East waving poorly photocopied books of mine, bought from a beach stall. Lines I have written are available on T-shirts and button badges not made or licensed by any of the people who represent me. It all just seems funny to me, and kind of great. If I were paid for it, I suspect I would earn a three-figure sum, which is different from the money I'd have lost if my US publishers didn't pay me. Digitization has made piracy maddeningly easy. If Dickens had known about the internet, he would have lost the rest of his mind.

But I know that I don't own my own work. I own the copyright but I sold the work, for money, to publishers, film companies, producers. They own it. That's the deal. That's how I get to work more. I know that I will never walk around with the word "SLAVE" written on my cheek because selling my work has brought me a great deal of freedom. I get to choose what I write and when I write it. And creating something that someone with a head for business wants to buy is a source of pride: it brings all this hot air somewhere close to the realms of a proper job.

But I wasn't abandoned by my mother, and I wasn't sent to work in a blacking factory when I was a kid. Global fame is never good for one's mental health anyway. And when you look again at those icons who grew up in poverty, you can see that sometimes the trauma of the past and the bewildering nature of the fame catch up with you. Marilyn died in her midthirties, Billie Holiday and Elvis in their early forties, Hendrix was a member of the 27 Club, Marvin was shot dead by his father, the ultimate example of how sometimes it's impossible to escape a difficult childhood. Perhaps the torment of Dickens and Prince was, by comparison, quite a small price to pay, and they got away with something—until they didn't.

Women

Women were their weakness. It's such a cliché that I am embarrassed to write the sentence, but it's true in ways that go way beyond the obvious, even though the obvious is (obviously) the first thing you see. Neither of them made their marriages work. Prince dated the one or two thousand most attractive women in the world, and married two of them. Neither of the marriages took, but the first, to the dancer Mayte, was surely affected by the loss of a child, born with a profound disability, in the first few days of his life. Dickens eventually separated from Catherine, his wife of twenty-two years and the mother of his ten children, after meeting the eighteen-year-old Nelly Ternan when he was in his forties.

None of this is particularly surprising. Prince did what a drop-dead gorgeous superstar often does, and

Dickens's behavior was hardly unprecedented, even in Victorian England. (It wasn't even unprecedented in his own family: two of his brothers, Fred and Augustus, deserted their wives.) Dickens's great friend Wilkie Collins lived with a mistress. George Eliot was living with a man who had left his wife—a wife who had had four children with another man, the editor of *The Daily Telegraph*. Adultery was a very serious matter, of course, and frequently spelled disaster and shame, but it happened, as it has happened throughout history. The more curious weaknesses lay elsewhere.

Prince's were less serious, despite the legions of women. They were, however, just as perplexing. Right at the beginning of Prince's career, before anyone had ever heard of him, just about, he took a shine to a local Minneapolis singer called Sue Ann Carwell. He wanted to write, play on, and produce an album for her. They recorded a couple of things, but nothing came from it, and in the end she made an album somewhere else. When Prince bumped into her again, he told her that her album was terrible—apart from her cover of "Company," the great Rickie Lee Jones song. He was angry—she was the one who got away, and at this stage, there was only one. Typically, though, the anger drops away for a moment when he's talking about a great song.

This is all very Prince. He wanted protégées right from the beginning of his career, before he even had a career to speak of. You'd think that trying to make it in the music business in one's late teens and early twenties is hard enough, without worrying about the fortunes of others, especially people who needed time and songs just when he needed both, too. But then again, songs were easy to come by for him.

And so, eventually, were protégées. He produced records for the group Vanity 6, and then the group Apollonia 6, when Vanity was replaced by Apollonia. And then there were Carmen Electra, and Jill Jones, and his first wife, Mayte Garcia, and Elisa Fiorillo, and Ingrid Chavez, and Sheila E., and Martika, and Bria Valente, and Andy Allo (Andy is a woman). It is impossible to tell how many of these were lovers—nearly all of them, according to the *Fashion Quarterly* website, which has never let me down before. Very few of the records he made with these beautiful young women are available now, and nobody seems to miss them much.

"He'd meet a girl and take her back to Paisley and record a double album with her overnight," said former manager Randy Phillips. "It would be ready the next day. Arnold [Stiefel, co-manager] had a conversation with him and said, 'Stop doing A&R with your

dick.'" Lots of rock stars have managed to seduce young women without having to write a dozen songs and produce a whole album for them, so this process was very particular to him, and seems to demonstrate— as if you couldn't have guessed from hundreds of his song titles—that sex and the creative process were very important to him. You know the sort. He couldn't so much as look at a girl without wanting to check her levels.

And yet his professional relationships with women seem to have been both fruitful and respectful. Lisa Coleman and Wendy Melvoin were invaluable contributors to the Revolution and the mountains of music he made during the 1980s. Drummer Sheila E. stayed in his band long after they had ceased to be lovers. Susan Rogers was one of very few female engineers working in music, and she wasn't an engineer until she met him—he promoted her very quickly. Her analysis of his apparently trailblazing feminism is a little disappointing, though. "If you wanted your own way of doing things, you shouldn't be working for Prince—and women are, it's safe to say, more inclined to let a man lead," she told *The Guardian*. "He also liked outsiders and liked feeling like one himself. There weren't many female technicians, so I was a rare bird and he liked the rare birds." For whatever reason, he always wanted

women in his band, perhaps a Sly and the Family Stone influence, and his last group, 3rdeyegirl, consisted entirely of women. It looked cool. "He loves voices, he's obsessed with great voices, with talent," the singer Mica Paris told *The Guardian* just after his death. "And he loves women, and I don't mean that in necessarily just a sexual way—I mean obviously he appreciates beauty—but he was crazy for talent. Just think of all those female musicians that he brought through who probably wouldn't have gotten a look-in if it wasn't for him."*

He loved the music women made, too. Joni Mitchell remembers him coming to see her play live when he was very young: "Prince attended one of my concerts in Minnesota. I remember seeing him sitting in the front row when he was very young. He must have been about fifteen. He was in an aisle seat and he had unusually big eyes," she said. Could she possibly have remembered, given that he wasn't yet Prince? But then, how many African American teenagers used to go and see Joni at the end of the seventies? He recorded a breathtakingly beautiful cover of "A Case of You," and

* The wayward tenses here illustrate how we all feel about an artist whose work we love and admire. Is Prince gone or isn't he? Is he brilliant or was he brilliant? He was brilliant live. He is brilliant in my living room.

bought her album *Hejira* from a local Minneapolis rec-
ord shop a couple of days before he died. He also gave
Joni to Lisa Coleman on her twenty-first birthday—
not an album, but the artist herself, who came to offer
Lisa her best wishes at Prince's behest. He loved Kate
Bush, and they ended up making a song together. He
tried to sign the Cocteau Twins, who were defined by
Liz Fraser's otherworldly voice. The dreamy, quiet,
folky side of Prince seemed to require a feminine muse,
as well as the lascivious side. He tried to pay back the
debts of influence he owed, too. He made two records
with Mavis Staples, at a time when everyone else had
lost interest in her, and another with Chaka Khan.
And he provided hit records for Khan ("I Feel for
You"), the Bangles ("Manic Monday"), and Sinéad
O'Connor ("Nothing Compares 2 U").

And it is O'Connor who has made one of the only
serious allegations to date about mistreatment, in her
memoir *Rememberings* and a couple of interviews she
gave to promote it. She said Prince was "involved in
Devil business," that the irises in his eyes disappeared
when she was talking to him, that he put something
hard in his pillow when they were having a pillow
fight, and that he was angry with her because he didn't
like people covering his songs. (This might come as
a surprise to the Bangles, Chaka Khan, the Pointer

Sisters, Alicia Keys, the Be Good Tanyas, Sheena
Easton, Mariah Carey, and literally hundreds of oth-
ers, with many of whom he maintained cordial rela-
tionships long after they had chosen one of his songs to
sing—or in some cases had been handed songs to sing
by Prince himself.) An ex called Charlene Friend tried
to sue him for defamation and emotional distress at the
beginning of the twenty-first century, but the case was
thrown out of court. Friend told the press that Prince
"believed he was the Messiah," which at least suggests
that she hadn't cooked up her story with O'Connor.
Given the trouble that magnetic and sexually hyperac-
tive superstars can find themselves in, his rap sheet
seems to me surprisingly short.

I had never seriously investigated Prince's love life
before writing this. I knew about the wives, and Sheila
E., and Kim Basinger, but I knew very few other
names. And I had kind of presumed that there would
be kiss-and-tell stories by both men and women, but
there is no evidence of the former that I can find. He
was that relatively rare creature, the androgynous het-
erosexual. "Officially, Prince wasn't gay," said the
critic Wesley Morris in a perceptive *New York Times*
piece. "But was he straight? On 'Controversy,' he rhe-
torically poses the question: 'Am I straight or gay?' . . .
And yet it never seemed to matter. Even after he

changed his name to the symbol of the male gender sign overlaid atop its female counterpart, he was always only ever *Prince*."

In the song "I Would Die 4 U," which, we should remind ourselves, came out in 1984, Prince says he is neither a woman nor a man. He was only half right when he went on to tell us that we would never understand. Most of us didn't understand back then. But it turned out that Prince's sexuality came from the future, and we finally got there—even someone like me, who grew up during a time when homophobic jokes provided nightly mainstream entertainment. Young people are explaining it to us, and it's deeply interesting. *Of course* gender is nonbinary, a spectrum, not two poles. We have known it all along, sort of, because throughout history there have been cultures and individuals who have exemplified nonbinary ways of doing things.

The Samoan Fa'afafine, who identify themselves as a third gender, are both very feminine and very masculine, whenever they feel like it. Anyone who has seen the terrific documentary *Next Goal Wins*, about American Samoa's attempt to qualify for the World Cup, will know that the very masculine side of their natures can involve playing in central midfield and kicking the shit out of the opposition, while looking ravishing off the pitch. The American evangelist known as the Public

Universal Friend (born Jemima Wilkinson in 1752) refused to acknowledge gendered pronouns, although they also preached abstinence, so they may not be as on point as I need them to be when discussing Prince's sexuality. (I am very glad to discover that there is a band on Spotify called the Public Universal Friend, as there should be.) There are countless examples over hundreds, probably thousands, of years, and we have always written them off as weirdos and outliers, never suspecting that they, like Prince, were showing us where we were heading.

"Lisa and I grew up knowing each other. We were budding lesbians, and by the time we were sixteen we fell in love with each other," Wendy Melvoin told *Rolling Stone* in an interview after Prince's death. "And two years later, they were shooting the 'Sexuality' video. I saw Prince doing the very final section of the video . . . I was standing in the room and I fell madly in love with the guy as I was watching him. I just couldn't believe that he was all of that and lived it, and he was it 100 percent."

So yes, Prince was a heterosexual man who loved women, but he was like a member of the sexual civil service: his personal views were his own, and they didn't affect his ability to do what he saw as his job (until the Jehovah's Witness years, anyway)—which

was to embody sex, onstage and on record, and whatever sex was to you was fine by him.

THE REAL MESS that Dickens made of his marriage was in the ending of it, and this mess came either because he knew he was regarded as a good man—a social reformer, a writer whose books demonstrated love and sympathy for the poor, and scorn for the rich and corrupt—or because he had come to think that way about himself. When rumors began to circulate about his private life, it seems as though he couldn't cope with the disapproval, and he lashed out, more than once, in calamitous ways. There are many moments in Dickens's life when one regrets that he didn't have the same resources and protection as a contemporary celebrity. Hollywood agents would have had a field day with the piracy and the knock-offs, for example. And right at this point, he was in urgent need of a PR adviser, someone who could shut a story down, or manipulate it to the client's advantage. And the first thing this adviser would have said is, "Don't write a whiny open letter about your personal life and give it to *The Times*."

But that's what Dickens went and did. The day

after it was printed in *The Times*, it appeared in Dickens's own magazine, *Household Words*. "By some means arising out of wickedness, or out of folly, or out of inconceivable wild chance," he wrote, "this trouble has been made the occasion of misrepresentations, most grossly false, most monstrous, and most cruel—involving, not only me, but innocent persons dear to my heart."

And there *were* persons, rather than a person, caught up in the gossip. Apart from Nelly Ternan, Dickens was also thought to have become improperly close to his unmarried sister-in-law, Georgina Hogarth. According to another great Dickens biographer, Peter Ackroyd, she was whisked off to the doctor in order to check that she was virgo intacta. (She was.)

Most people who are famous because of their art tend to overestimate how famous they really are, unless they are actors in a soap, or A-list movie stars. If you are a writer lucky enough to sell half a million copies of a paperback in the UK, that means roughly forty-nine and a half million adults in the UK have not bought it. Some of these people might borrow a copy from a library, or from a friend, but the overwhelming majority will have no interest in buying or reading it.

Being a famous writer is not quite the same thing

as being famous. Dickens was a very famous writer, famous in a way almost nobody has experienced since. But nobody knew anything about the shambles going on behind his front door: partitions in the marital bedroom, children being forced to choose between parents. He made the elementary famous-writer mistake of thinking that the public must have known, because it was the talk of literary London—the metropolitan elite, as it's known now, and as it was, even then. Once he wrote about it in the newspapers, however, everyone knew. He didn't spell out what was going on. He simply referred, angrily and sorrowfully, to events and reactions and bad behavior that he presumed were common knowledge—which gave every newspaper and magazine carte blanche to spell out what was going on, as far as they could tell, simply as a service to their readers. *Reynolds's Weekly Newspaper* gave a representative example of the general repugnance (and salaciousness) in an editorial saying that "the names of a female relative, and of a professional young lady have both been, of late, so intimately associated with that of Mr. Dickens, as to excite suspicion and surprise in the minds of those who had hitherto looked upon the popular novelist as a very Joseph in all that regards morality, chastity and decorum." Dickens's skin was apparently becoming thinner with each passing year,

and his response was rage. He talked to his friends about how ill-used he had been by his wife and his mother-in-law, and if these friends were insufficiently sympathetic, there were rifts and harrumphs. His friendship with Thackeray was damaged beyond repair, and the now-infamous letter earned him the worst reviews of his career from his peers, although the disapproval was mostly expressed in private. There was a cost for all this, but it wasn't Dickens the novelist who had to bear it. The separation happened in 1858; starting in 1859, he wrote two novels in two and a half years. The first was *A Tale of Two Cities*, and the second was *Great Expectations*.

But what was a famous writer in his mid-to-late forties doing, falling in love with eighteen-year-old Nelly Ternan? He had form: a much earlier infatuation with another eighteen-year-old when he was in his thirties, a young woman who apparently bore a resemblance to his wife's sister Mary, who died when she was seventeen, a death that devastated Dickens. Such was the intensity of his grief—Peter Ackroyd describes it as "the most powerful sense of loss and pain he was ever to experience . . . amounting almost to hysteria"—that one can't help but wonder what she signified. We are all, of course, very fond of our sisters-in-law, but given that Dickens had yet to live through the deaths of his

parents and two of his own children, this strikes one as odd. Ackroyd thinks that his wife "now represented the adult world of responsibility and work," whereas Mary for him was "young, beautiful and good." He had those three words inscribed on her gravestone, and he used those three words to describe Rose Maylie (in *Oliver Twist*), Little Nell, and Florence Dombey. He described Christina Weller, the eighteen-year-old who people thought resembled Mary, as "too good," "spiritual young creature that she is, and destined to an early death, I fear." (She died in 1910, aged eighty-five.) Whatever is going on here, it doesn't seem to be particularly healthy, and the jumbling of sexual feelings with some kind of yearning for childhood innocence reminds one not of Prince, but of Michael Jackson.

Certainly it didn't help his writing. Young attractive women were his weakness: he was hopeless at them. The older women in his fiction, many of them grotesques and caricatures, are among the most memorable in all of literature: Mrs. Gamp, Madame Defarge, Betsey Trotwood, Peggotty. Miss Havisham and Mrs. Jellyby have shaken off their novels and walked into our language. But the young romantic leads tend to be irredeemably drippy. Esther Summerson, who narrates half of *Bleak House*, is a drip. Lucie Manette in *A Tale of Two Cities* is a drip. Dora Spenlow in *David*

Copperfield is such a drip that David seems destined to leave her because of her drippiness, but she conveniently dies first.

Dora is perhaps the most interesting, not only because *David Copperfield* is Dickens's most autobiographical novel, and it's impossible not to wonder about his marriage to Catherine, but because he effectively turns on her—he invents the kind of child-woman you don't see in life, only in Dickens novels, and then dumps on her. The suspicion is that it wasn't ability that prevented him from writing a rounded, authentic-seeming ingénue; it was something dammed up deep in him, something that flooded him when Mary Hogarth died, and he never seemed to get his head above its water. There's another modern professional Dickens needed, on top of a Hollywood agent and a media adviser: a therapist.

The End

The End

In the 2010s, the last few years of Prince's life and therefore his recording career, we were overwhelmed by plenitude. Anyone with a subscription to a streaming service suddenly had the ability to listen to nearly all the music ever made, and those of us with a lifetime addiction suddenly found ourselves getting itchy. I could read a review of an album and listen to it there and then, for literally nothing, but of course I didn't listen to all of it—I listened to the opening track, the first few bars, and immediately began to wonder whether the review *underneath* the review I'd just read would lead to a better or richer or more fashionable listening experience. And then there was the sudden availability of all the stuff I'd forgotten about from my teens, and the stuff I used to own on vinyl and had sold, and the cool old stuff I'd always meant to listen

to and had never found the time or money for in the old days, and the sudden ability to investigate the back catalogs of artists I'd only discovered relatively recently . . . (Aided and abetted by Spotify, I developed a love for Duke Ellington and Count Basie, whose output between the 1920s and the 1970s will take care of all the listening time you have available for months.) These were the circumstances in which Prince chose to send out album after album. It was very easy to lose track, has remained easy to lose track, of a favorite artist, especially when that favorite artist is gushing out songs as if they were water from a tap, and they are no longer getting the media attention they had previously enjoyed. The last album released during his lifetime, *HITnRUN Phase Two*, got the same critical response that his albums usually received from the 1990s onward. The first review that comes up on Google says it "may be Prince's best album in a decade or two"; the next says "it's an underwhelming entry in . . . Prince's canon."

This has happened to a great many artists, especially older artists, especially over this last decade, the Decade of Too Much Everything, but, incredibly, it happened to Dickens, too. There is a line in Claire Tomalin's biography that made me stop dead and reread it: "*Bleak House* was ignored in the chief critical reviews,

the *Edinburgh*, the *Quarterly* and the *Saturday*" . . . Hold on. *Bleak House*? The book that first introduced me to Dickens's greatness? The book that has been read and reread for the last one and three-quarter centuries? *Jarndyce v. Jarndyce*, the fictional case that has entered the language? The book that became, in the twenty-first century, arguably the best of all the screen adaptations, the fifteen-part BBC drama written by Andrew Davies, starring Gillian Anderson, Johnny Vegas, Carey Mulligan, and Charles Dance, and watched by between five and seven million twenty-first-century people? The novel that the critic and novelist Philip Hensher (in a piece for *The Guardian* entitled "You'll Never Catch Me Watching It," written to coincide with the TV series) described as "the greatest novel in the English language"? Dickens couldn't get *Bleak House* reviewed? Really?

In his article, Hensher quotes a *Daily Telegraph* journalist who provides an unwittingly comic example of how the whole critical process works. "To those who have plowed through all 1,088 pages of Charles Dickens's novel *Bleak House*," said the journalist, "it may seem like an unlikely book to be transformed into a populist drama." Argh! Oh my God! "Populist" was exactly what it was! That was why it didn't get reviewed by the snootier literary magazines! It was published in

twenty parts, and forty thousand readers bought every issue. "Dickens spoke to the people, and the people responded, and saw that *Bleak House* is among the greatest of his books," Tomalin says. How funny, then, that all those years later, its survival—and apparently its length—has taken it away from the people, and it is held up as the antithesis of populism, at least by *The Daily Telegraph*. The immutable law of culture: if anything popular survives, it somehow becomes the property of the educated elite. The same thing happened to Shakespeare.*

Dickens was forty when he began *Bleak House*, and there were many great books to come, but there was a sense that he was becoming a prophet without honor in

* This journey—*de bas en haut* and back again—happened most dizzyingly in 2021, when Judge Timothy Spencer, QC, appeared to sentence a twenty-one-year-old white supremacist called Ben John to reading *A Tale of Two Cities* and *Pride and Prejudice*, among other works of classic literature. The judge then invited John back to court so that he could be tested on what he had read. (His scores are unknown at the time of going to press, although some commentators are suggesting that the punishment is too lenient for a young man who had downloaded 67,788 documents, much of it anti-Semitic in nature, and instructions on how to construct a bomb.) There was a time, around about 1859, when any literate criminal would have been delighted to get their hands on a copy of *A Tale of Two Cities*, which is why no judge would have meted out the sentence. Dickens was just too much fun. Now, a romantic thriller about the French Revolution is regarded as "improving," and is considered to have the mystical power to save white supremacist souls. The obtuseness, snobbery (Harry Potter and Lee Child would do every bit as purposeful a job, surely), and confusion of Judge Timothy Spencer would require a book all to itself to explore.

his own country. His last completed book, *Our Mutual Friend*, was greeted with a stinker of a review by Henry James: "It were, in our opinion, an offense against humanity to place Mr Dickens among the greatest novelists . . . He has added nothing to our understanding of human character." (How's the twenty-first century working out for you, Henry?) Nobody, apart from huge numbers of the American English reading public, liked *A Tale of Two Cities*, and *Little Dorrit*, too, would have received a Rotten Tomato on the aggregator website. Only *Great Expectations*, which was seen as a throwback to the earlier, funnier work, got anything like the kind of admiration that history shows those last half-dozen novels deserved.

But the addiction to work went on, for both of our central characters. We know that Prince's favorite thing to do after a show was to play another show. Sometimes these were advertised in advance, sometimes the location spread through word of mouth; sometimes he'd turn up at midnight, sometimes at three o'clock in the morning. Once, early in his career, in the middle of a forty-date tour, he asked the band playing a frat party at the Holiday Inn in Charlotte whether he and his band could play during their break. (Permission was granted.) "When Prince played in your city, you waited around for news," longtime fan Ben Greenman wrote

in his book *Dig If You Will the Picture: Funk, Sex, God, &
Genius in the Music of Prince*. "People would start to whis-
per. Maybe a club in town would cancel their regularly
scheduled dance party for a 'special event' or book an-
other with a suspiciously generic name ('Celebration of
Music')."* As Greenman points out, lighting cues and
choreography prevented the "real" shows from straying
too far into the realms of the spontaneous. The after-
shows, however, meant you might hear any Prince song,
or any song by any other artist, at any moment: the
Staples' "I'll Take You There," Hendrix's "Spanish
Castle Magic," Sly Stone, Al Green, the Stones, Lenny
Kravitz, Santana, the Meters, Creedence Clearwater
Revival, Miles Davis, Chuck Berry, the Commodores,
lots of James Brown, Joni Mitchell, a history of every-
thing he had ever loved. These shows—and remember,
they were *aftershow* shows—were frequently two or three
hours long. Has anyone expressed a commitment to
their art as loudly and as clearly? All musicians love to
play live, but there aren't too many who want to play

* The BBC journalist Nick Robinson decided to celebrate his thirty-
ninth birthday at a seventies-themed disco in an unprepossessing venue
in a shopping mall in Islington, North London. When he and his party
arrived, the bouncer on the door told them that the disco was no longer
taking place and offered them their money back. They went in anyway,
and were treated to a full Prince set, with a band.

live, for hours, after they have played live. "We'd do a show and then he'd want us at a club at 2 a.m.," said former protégée and onetime bandmate Elisa Fiorillo. "So many aftershows would go on to six in the morning. People would chant in the audience, 'Six in the morning!' My poor feet!"*

I never went to an aftershow show, although I have heard recordings of several of them. I always meant to. I thought I had time.

But time was in short supply, for both of them. As you may remember, neither of them lived to see sixty, and the conventional wisdom, I suppose, would be that the years they lost were crammed into the lives they actually lived, but the "extra" work had vigor and ferocity—there wasn't any elegiac, late-period reflection. Just as some footballers who start playing in their midteens don't have much of a career post-thirty, it looks from here as though the sheer amount of writing, recording, and playing made an old age impossible.

Dickens's novels total something like four million

* Fiorillo made a couple of solo albums at Paisley Park in the late eighties and early nineties, sang backup on a couple of Prince albums, and then drifted out of the business altogether. She was working in real estate when in 2009 Prince called her after seeing a couple of YouTube clips of her singing and asked her to join his band. This eccentric route to the stage was probably only possible in Prince's world.

words. I am six years older than he was when he died, and I doubt I've got to seven hundred and fifty thousand words yet. And yes, in recent years I have written more screenplays than I have books, but there aren't many words in screenplays. With Dickens, though, the novels were only a part of the job. There were the letters, for a start: he received between sixty and eighty a day, and replied to most of them himself. Look at the twelve-volume edition that Graham Storey edited for Oxford University Press and you think, yep, that's not a bad life's work. Volume 12 is 842 pages. Volume 6 is 936 pages. Volume 7 is 1,004 pages. There were fourteen thousand letters by the time the most recent edition was published in 2002, but newly discovered ones—about twenty a year appear—are put up on the Charles Dickens Letters Project website. They are obviously an invaluable literary resource, but they also serve as the closest thing we'll get to an autobiography, and many of them are great—funny or angry, or both.

But it wasn't just the letters and the novels. There was the journalism, which continued until the year of his death. Penguin published a *selection* of the pieces he wrote between 1850 and 1870—the two decades in which he wrote six complete novels, including three over three hundred thousand words long, and that book is seven hundred-odd pages. But it wasn't just the

letters and the novels and the journalism. There was the editing work he did, and the committees he sat on, and of course the punishing readings, which frequently led to him lying on the floor after the more dramatic performances. Claire Tomalin tells us that his complicated love life involved "at least sixty-eight" trips to France between 1862 and 1865.

When Robert Douglas-Fairhurst writes about Dickens's activities in the spring of 1851 in *The Turning Point*, you could be forgiven for thinking that he was either an actor-manager or a social reformer. He had nabbed a plum part for himself in his friend Bulwer-Lytton's play *Not So Bad as We Seem*, a gala performance of which took place at Devonshire House in April; he was rehearsing for at least five hours a day, sometimes drilling his amateur company into the early hours. Meanwhile, "carpenters, scene painters, tailors, boot-makers, musicians, all kinds of people, require[d his] constant attention." But attention was also needed elsewhere, at Urania Cottage, a home for fallen women that he had persuaded his wealthy friend Angela Burdett-Coutts to pay for. He had written a prologue for the girls that was read to them on their arrival, and they wore costumes that he had chosen for them. He had drawn up their timetable, he recruited them, he knew their names and their successes and failures. (Believe it or not, Urania

Cottage was a positive and cheerful environment compared to the shame-and-religion-soaked alternatives, usually run by Anglican nuns, which Dickens described as "pernicious and unnatural.") Meanwhile he was editing, walking, writing letters, sitting on committees.

Of course all this killed him, as it would kill any of us. Indeed, the index of Peter Ackroyd's biography makes you marvel that he lived as long as he did: under the "Health" heading there are entries for bilious attacks and nervous prostration, depression and near-breakdown, erysipelas (a skin infection), facial pains, headaches, illness after attack by horse, inflamed ear, kidney trouble, nervous exhaustion, piles, reaction to railway accident, rheumatism, spasms and seizures, stomach pains, stroke, and swollen foot and lameness (vascular disorder). Tomalin, through some careful decoding of the letters, suggests that he had gonorrhea too, apparently as a result of the time he spent without a regular sexual partner before things had properly got going with Nelly.

One must presume that sleep would have been a casualty of both Dickens's energy and his bouts of ill health; his incessant walking, some of which took place at night, suggested that he rarely got his seven hours. Famously, one night he walked from his London home to his house in Kent, a distance of thirty miles, in order

to escape the misery of his domestic life, but usually he walked twelve miles a day at an average speed of four miles per hour. (If he had written no novels, no letters, no journalism, but had only walked, one still might have ended up thinking that he had a busy life. Walking, ten kids—who has the time for work?) Interestingly, Dickens was such an acute observer of sleep disorders that obesity hypoventilation syndrome (OHS) is also known as Pickwickian syndrome, because Joe, the Fat Boy in *The Pickwick Papers*, clearly suffers from it, and Dickens's description seems to be the first. Such was the author's preoccupation with sleep and its miseries that there is a paper entitled "Charles Dickens: Observer of Sleep and Its Disorders," written by J. E. Cosnett for the American Sleep Disorders and Sleep Research Society. At various stages his characters suffer from insomnia, night terrors, sleep automatisms (sleepwalking and other unconscious involuntary activities), and hypersomnia. A description of Oliver Twist's sleep paralysis—"There is a kind of sleep that steals upon us sometimes, which, while it holds the body prisoner, does not free the mind from a sense of things about it, and enables it to ramble at its pleasure"—predates the first medical description of the condition by forty-odd years, according to Cosnett. Sleep was frequently on Dickens's mind, it appears,

and he thought about it, observed its torments and its elusiveness with a great deal of care.

In one of the smartest and most beautiful pieces of Dickens lit-crit, G. K. Chesterton links the sleep and the walking together:

> Herein is the whole secret of that eerie realism with which Dickens could always vitalize some dark or dull corner of London. There are details in the Dickens descriptions a window, or a railing, or the keyhole of a door—which he endows with demoniac life. The things seem more actual than things really are. Indeed, that degree of realism does not exist in reality: it is the unbearable realism of a dream. And that kind of realism can only be gained by walking dreamily in a place; it cannot be gained by walking observantly.

So Dickens walked, in a semiconscious state, according to Chesterton, often instead of sleeping, and reading these words while thinking about his health, it's hard not to wonder whether it wasn't just his workload that made him ill, but also his strange, occasionally otherworldly talent.

Look at the photographs taken of him toward the

end of his life, and you don't see a man in his fifties. He looks at least twenty years older.

And when death came, it came both suddenly and in slow motion, with lots of indications of its arrival, and lots of apparent attempts to push it away. In the last year or two there was a stroke, and then the early and successful episodes of *The Mystery of Edwin Drood*, and parties, and committees, and hemorrhages from piles, and a meeting with Queen Victoria, and lauda- num, and his energetic, exhausting readings, and lame- ness, and blurred vision, and then, eventually, a collapse. He died at home, but there is a real possibility that the

beginning of the end, the fatal seizure, took place with his mistress, Nelly Ternan, in the house that Dickens paid for in Peckham, southeast London, and that he endured what must have been an agonizing coach journey lasting hours so that he could die at home in Kent, surrounded by family. This theory has grown from a fantastically novelistic detail. He had cashed a check for £22 the day before he died, but his sister-in-law found £6 6s 3d when she went through his pockets postmortem. He paid Nelly housekeeping money. The first chapter of A. N. Wilson's book *The Mystery of Charles Dickens* is entitled "The Mystery of Fifteen Pounds, Thirteen Shillings and Ninepence." If this version is true, then it was an exhausting, restless death, an appropriate end to an exhausting life—more motion, right to the end, for a man who never stopped. Wilson even speculates—or, as he puts it disingenuously, "one does not need to speculate"—that he was killed by his need to live life to the full: "Clearly Dickens, the father of ten children . . . was a highly sexed man who brought to the life of love the same exuberant hyper-energy that he also brought to the love of life." That is a death that could have been imagined for the other subject of this book.

Prince's death was foretold, too. A few days before he died, his private plane had to make an emergency

landing in Illinois after a concert in Atlanta, and he was reportedly given a shot of the anti-overdose drug Narcan by local emergency services. Narcan is so widely used in the US that it has become controversial. "Stop giving them Narcan! At the tax payers expense," an angry poster commented under a story in a local newspaper about two parents who had been found unconscious while their children played nearby. As Margaret Talbot described in a devastating piece for *The New Yorker*, many opioid overdoses are found outside, because it gives one a better chance of staying alive; you're less likely to die if you take your fentanyl, one hundred times stronger than morphine, by the side of a basketball court or in a restaurant toilet rather than at home, where nobody will find you until it is too late. Prince's millions meant that he had a pretty close call. He wasn't in a public space. He was in a private plane, high up in the air.

The next day, back in Paisley Park in Minneapolis, he cycled to a record store to buy albums by Santana and Stevie Wonder, and he hosted a party that night. A couple of days later, he went to see a show in a local club. He also saw a doctor to get a prescription. The night before he died, something slightly odd happened: someone on his staff called a doctor called Howard Kornfeld in California, who specialized in treating

addictions. Because he was unable to respond immediately himself, he sent his son Andrew, a colleague at his practice, to Minneapolis that night. There is something haunting about the sudden, desperate recognition of the scale of the problem, as if someone knew that Prince was going to run out of luck: there is no quick fix for addiction, but Kornfeld's son knew that he had to move fast. When Prince overdosed for the second time that week, his millions counted against him. He was found dead in his own private elevator, on his private estate, too far away from everybody, too hidden, to receive the magic shot. The elevator, the carriage from Peckham to Kent—there is still movement, even in the last moments.

Andrew Kornfeld was the one who called 911 when the body was found. Howard Kornfeld, with wearying predictability, had a wrongful death lawsuit brought against him by members of Prince's family, who argued that he should have advised Prince's associates that he must be admitted for treatment immediately. The case was thrown out because there was no evidence Kornfeld had ever spoken to Prince, and thus they had no doctor–patient relationship. Whoever was panicking that night, it wasn't Prince, who was presumably in no fit state to do so.

Very few people knew Prince was addicted to pain-

killers, an addiction that probably began when he was trying to deal with a painful hip condition. He didn't even seem to know himself—those in his circle suspect he didn't know quite what he'd gotten himself into. There is little doubt that the hip condition was caused by nearly forty years of concerts, concerts that involved a blur of movement, every night. He was a dancer, and dancers aren't built to last. Too many pieces become frayed and torn. He was famously clean-living, anti-drugs, vegan, and drank a little red wine in moderation, as per the teachings of his church. If Dickens looked like a septuagenarian when he died, Prince looked like a man in his thirties, although maybe you can see a little puffiness in his face during the last shows. If the two men had been born on the same day, they'd have been dead within six months of each other. Thirty-five or seventy-five, it doesn't matter. Those extraordinary creative brains must have been a thousand years old.

They have both lived on, of course, but more vigorously than one might have expected, and in surprising ways. For example: Noel Fielding mentioned Prince after eight minutes of the first episode of *The Great British Bake Off 2021*; fourteen minutes later, he referred to Dickens, too. Neither of the references seemed weird, or forced, or in response to a financial inducement from the publishers of this book. They were used for

jokes about outlandish glamour and the class divide, respectively. They are very close to hand when we need quick, easy, and comprehensible illustrations.

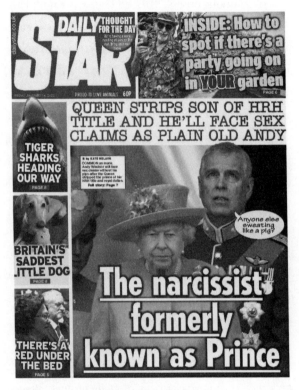

Prince lives on, 2022

Dickens is still read, and not just because he has to be by reluctant students. And his work still supplies our nonliterary culture with a steady stream of material. In 2015, there was a BBC series called *Dickensian*, in which

characters from various novels came together to investigate the death of Jacob Marley. In 2021, there was a contemporary thriller called *Twist*, a gangster movie starring, among others, Michael Caine as Fagin; Fagin was also the star of a Will Eisner comic book called *Fagin the Jew*, published in 2003. There is an extra feature in the video game *Assassin's Creed* called "Our Mutual Friend," according to the *Assassin's Creed Syndicate* Wiki page (and, like *Fashion Quarterly*, this source has been impeccably reliable in my literary research hitherto).*

There have been four movie or TV adaptations of *Great Expectations* in the last decade, including the Indian film *Fitoor*, and Armando Iannucci's brilliant *The Personal History of David Copperfield*, with a marvelous color-blind cast. Claire Foy played Amy Dorrit before she was old enough to play the queen, for the BBC;

* "Our Mutual Friend is one of the Darwin and Dickens Conspiracy Memories," says the Wiki page helpfully. "It's a level 6 mission, and found in Westminster. This begins with you needing to find John Hammon. He is inside the nearby train station, so head there, speak with him, then slowly lead him outside the station. When you get near the exit, you are jumped by a few enemies. Deal with them, then pick up the marked body. You need to take him to the Thames . . . Toss the body in the water, then head to the next area. Once you get there, speak with the woman and the mission will end." Well. Yes. That's the novel, more or less.

there is simply no counting (I have tried) the number of twenty-first-century adaptations of *A Christmas Carol* across all media—animated films, puppet dramas, the works. There are, regrettably, a number of movies called *A Tale of Two Titties*, but these do not seem to follow the plot of the book.

Meanwhile Prince is effectively alive, as far as his recording career goes. Postmortem we have been given special editions of *Purple Rain* and *Sign o' the Times*, both of which contained unreleased material, and a solo demo album called *Piano & a Microphone 1983*, and an album called *Originals*, consisting of the demos of songs he gave to other people. In 2021, we had *Welcome 2 America*, a new collection of songs recorded with a band in 2010 but not released at the time. This means that someone, finally, is digging into Prince's vault and trying to organize it.

That someone is a man called Troy Carter, who used to work for Spotify and managed Lady Gaga. He and a team of archivists have moved the vault from Paisley Park to a climate-controlled Iron Mountain storage facility in Los Angeles. Nobody knows how much material is in the vault; maybe Troy Carter doesn't know yet, because he's only had three years to get to grips with it, but the estimates range from five thousand to eight thousand unreleased songs, or a ten-

song album every six months for the next three or four hundred years. I'll bet there are some good ones in there.

I have lived long enough now to see the reputations of dead artists rise and—more usually—fall over decades. Does anyone still talk pretentiously and in absolute ignorance about Sartre and the Existentialists, as my fellow teenagers and I did in the last year of school? Has Bellow crossed over into the twenty-first century from the twentieth? (If you remember loving him back in the day, you may want to read or reread *Henderson the Rain King* through the eyes of your fierce children.) Is Dalí beginning to look a bit daft? Is there a hunger among young people for the prog rock of the 1970s? Dickens has won his case. If he dies out, if his novels cease to be read, it's because novels, too, are dying out, which of course may yet happen.

His critical reputation has fluctuated since his death. Virginia Woolf, predictably, was sniffy—his "sentiment is disgusting and his style commonplace." Huxley banged on about his vulgarity. Slowly, over the next few decades, he was rescued by more perspicacious critics; but even on the occasion of the two hundredth anniversary of his birth in 2012, the critic John Sutherland was telling us, in an article entitled "Enough with the Charles Dickens Hero Worship," that *Vanity Fair*

"is a greater novel than anything Dickens penned" and that Wilkie Collins's *The Moonstone* "beats . . . *Bleak House* into a cocked hat." Curiously, Sutherland seems to have written the article to promote his book *The Dickens Dictionary*, a book with the subtitle *An A–Z of England's Greatest Novelist.* Now, as then, there is more money to be made from Dickens than from any of his rivals.

And at the moment it's hard to see Prince fading away, especially if he releases two good albums a year for the next few centuries, even after those twentysomethings who went to see *Purple Rain* in the cinema are gone. "He was his own genre," Questlove wrote. It's hard to say that you don't like his music, because his music was everything you've ever loved—scrambled, revolutionized, painted different colors. Maybe you're sick of "Purple Rain," but somewhere on that enormous *Sign o' the Times* box is a song you'll adore, because it contains multitudes. And that's before you get going on the rest.

But it doesn't matter to me whether they last or don't last, or whether you like them or not. That's beyond the scope of this book. What matters to me is that Prince and Dickens tell me, every day, Not good enough. Not quick enough. Not enough. More, more, more. Think quicker, be more ambitious, be more imaginative. And

whatever you do for a living, that's something you need to hear, every now and again. Were they happy? Probably not. Were they crazy? Probably. That, too, is beyond the scope of this book. This book is about work, and nobody ever worked harder than these two, or at a higher standard, while connecting with so many people for so long. That's why I have photos of them both on my office wall. They will stay there for as long as I need them, which will be for the rest of my life.

ACKNOWLEDGMENTS

Thanks to Georgia Garrett, Mary Mount, Tony Lacey, Sarah McGrath, Robert Douglas-Fairhurst, Ben Greenman, Lucy Chavasse, Mary Chamberlain, John Crowley, and Luke McKernan.

Select Bibliography

Books

Claire Tomalin, *Charles Dickens: A Life*, 2011.

George Orwell, 'Charles Dickens' from *Inside the Whale*.

John Sutherland, *Victorian Fiction*, 1976.

Alex Hahn and Laura Tiebert, *The Rise of Prince*, 2017.

Prince, *The Beautiful Ones*, 2019.

John Carey, *What Good are the Arts?*, 2005.

Caroline Stafford and David Stafford, *Fings Ain't What They Used T'Be*, 2011.

Annie Dillard, *The Writing Life*, 1989.

Anne Lamott, *Bird by Bird*, 1994.

Leon Edel (ed.), *Henry James: Selected Letters*, 1987.

Select Bibliography

Michael Slater, *Charles Dickens*, 2009.

Charles Dickens, *The Pilgrim Edition of the Letters of Charles Dickens: Volume 6: 1850–1852*, 1988.

Robert Douglas-Fairhurst, *Becoming Dickens*, 2011.

————*The Turning Point: A Year that Changed Dickens and the World*, 2021.

Peter Ackroyd, *Dickens*, 1990.

Matt Thorne, *Prince*, 2008.

Ben Greenman, *Dig If You Will the Picture: Funk, Sex, God and Genius in the Music of Prince*, 2017.

Duane Tudahl, *Prince and the Purple Rain Era Studio Sessions: 1983 and 1984*, 2018.

Laurence W. Mazzeno, *The Dickens Industry*, 2008.

A. N. Wilson, *The Mystery of Charles Dickens*, 2020.

Articles, blogs, and media

Questlove, *Rolling Stone*, "Questlove Remembers Prince," 2016.

Scott Barry Kaufman, *The Guardian* (London), "What is Talent?," 2013.

Chuck Arnold, *Billboard*, "Prince Collaborator Chris Moon Remembers Mentoring Legend Before the Fame," 2018.

Select Bibliography

Robert Christgau, *The Village Voice*, 1980.

Luke McKernan, LukeMcKernan.com, "Walking with Charles Dickens," 2013.

Brian Raftery, *Spin*, "Prince: The Oral History of 'Purple Rain,'" 2009.

ThisIsTheatre.com, "Hard Times the Musical."

Pauline Kael, *The New Yorker*, *Purple Rain* review, 2018.

Guardian, "Ten Rules for Writing Fiction," 2010.

David Gates, *Salon*, "Portrait of the artist as a minor character," 2000.

Newsweek, "Reports from the Heartland," 1991.

Susan Rogers, Daily.RedBullAcademy.com, "Susan Rogers on Working with Prince," 2017.

David Stubbs, *The Guardian* (London), "Jimmy Jam and Terry Lewis," 2016.

Andrea Swensson, *The Current*, "Prince: The Story of *Sign o' the Times*," 2020.

Lucy Mapstone, *Belfast Times*, "Unseen Letters," 2020.

Alison Flood, *The Guardian* (London), "Oliver Twiss and Martin Guzzlewit," 2019.

David Browne, *Rolling Stone*, "Prince in the Nineties," 2016.

Select Bibliography

Ben Beaumont Thomas, The *Guardian* (London), "Prince's sound engineer, Susan Rogers: 'He needed to be the alpha male to get things done,'" 2017.

Tom Taylor, *Far Out Magazine*, "Prince's favourite song of all time," 2021.

Wesley Morris, *The New York Times*, "Prince Knew What He Wanted," 2016.

Katherine Turman, Esquire.com, "One Year After Prince's Death," 2017.

Andy Gill, *The Independent* (London), "Prince: HitnRun Phase Two," 2015.

David Drake, *Pitchfork*, "HitnRun Phase Two," 2016.

Philip Hensher, *The Guardian* (London), "You'll Never Catch Me Watching It," 2005.

Catriona Davies, *Daily Telegraph* (London), "Dickens epic becomes *EastEnders* in a crinoline," 2005.

John Sutherland, *The Guardian* (London), "Enough with the Charles Dickens Hero Worship," 2012.

Prince and The Revolution, "Let's Go Crazy," *Purple Rain*, 1984.

Joe Levy, *Slave Trade* documentary, 2014.

David Kluft, TrademarkandCopyrightLawBlog, "Charles Dickens and Copyright Law: Five Things You Should Know," 2017.

Select Bibliography

David Browne, *Rolling Stone*, "Inside Prince's Final Days," 2016.

Catherine Waters, *The Conversation*, "Charles Dickens: 150 Years On, Debate Still Rages Over His 'Misogynist' Label," 2020.

J. E. Cosnett, Just: Sleep, "Charles Dickens: Observer of Sleep and Its Disorders," 1992.

Meir H. Kryger MD, Elsevier.com, "How Charles Dickens Inspired a Breakthrough in Sleep Medicine," 2013.

Lucinda Hawksley, ALCS.co.uk, "Charles Dickens, Copyright Pioneer," 2015.

Lauren Cochrane, *The Guardian* (London), "The Women Behind Prince," 2017.

Mica Paris, *The Guardian* (London), "Prince: Memories of U," 2016.

Carra Glatt, *Nineteenth Century Studies*, "When Found, Make a Note of: Tracing the Source of a Dickensian Legend," 2014.

About the Type

This book is set in Baskerville, a serif typeface designed by John Baskerville in the 1750s. Categorized as a "transitional typeface," it is known for its sharp serifs and soft, circular curves, and is loved for its elegance and legibility.